Copyright © 1998 Susan
13435 N.E. Whitaker Wc
PH(503)254-9100

D1085935

Congratulation on your decision to find out more about watercolor and acrylic painting with Susan Scheewe. I sincerely hope that this first step will begin your journey to the satisfaction found in painting.

Many people have different ideas about what it "takes to paint" but I have found there is only one requirement - a desire strong enough to pick up a brush for the first time. With my easy to learn techniques and methods, you will find that the rest will take care of itself. Painting with me is so much more simple and enjoyable than you could have imagined.

I wish you every success in your new journey.

Most of the paintings in the book have been shown on Public Broadcasting "Sue Scheewe Art Workshop" Series. Call you local P.B.S. television station for information. It is my hope that this book and the television series will help you better understand many of the different ways to approach watercolor and acrylic and encourage you to pick up a brush. Painting is so much fun and not only rewarding for yourself but also bring for those that you give your painting to. The fear of picking up a brush and worry about making a mistake in class can be overwhelming but you can start to build you confidence at home and you'll surprise yourself.

My family is the most important thing in my life. While I can't share my fabulous family, I can share my years of learning and teaching. While often there are several ways to approach a painting, I've tried to explain easy to follow techniques and instructions.

"GETTING TO KNOW YOUR COLORS"

COLOR CHART

It is really important that you know your colors. Make a color chart that is placed in the front of your notebook. The color chart will soon become a valuable reference. As you add colors to your palette take the time to add them to your color chart. Make sure you label the colors as you paint the chart.

Be sure you have a clean brush and clean paper towels. Apply pigment in a line working from left to right. Dilute the pigment with water as you work toward the right side to lighten the value.

COLOR MIX FILE

Make an area in your notebook to keep color mixes. These mixtures should be labeled and can be made from scrap watercolor paper or maybe from the backside of a painting that didn't go as planned.

I realize most of you feel mixing color can waste paper but believe me it truly is worth the time, effort and expense of a little paper.

As you mix your pigment make several variations, using more or less of one of the pigments. Be sure to label the mixtures. As you experiment with color you will be making some delightful surprises.

GLAZING

Glazing is an important technique when painting with watercolors. It is most important that each layer of color be completely dried before another layer is applied over the top. Glazing provides a luminosity that you can not obtain by any other method. This is important to include in your notebook.

Glazing is applying thin transparent layers of diluted pigment over the top of another dry layer, allowing the bottom color to show through slightly and alter the appearance of the prior application. It is much like layering cellophane or stain glass, once laid over each other the appearance changes. An example would be taking yellow and overlaying blue, it would have a green appearance.

You can speed up drying by using a hair dryer. Be careful not to turn on full blast close to the paper as you could move the pigment. Do not use a hair dryer in combination with the frisket as it could cause the frisket to bond to the paper and make removal difficult if not impossible. Should you use a hair dryer be careful to wait for the paper to cool, warm paper would speed the drying process and make a hard line or create difficulty in manipulating an even flow of color. Should you apply another layer before the first layer has dried the pigment will blend and alter the results.

Paper will also greatly effect your results. It is important to use a test paper that you are using to complete your painting.

Be careful not to scrub hard when you are layering colors as you could cause blending or a blotch result. Overworking an area could dissolve the wash below.

MIXING COLORS

While there are many beautiful color variations that can be made from primary colors there is a limit to the possible bright colors you can achieve. By purchasing the secondary colors you can gain a broader spectrum of lightness, brightness and color.

WATERCOLOR PALETTE

The Martin/F Weber Company asked me to design a palette that I would like for watercolors, what a privilege. While there are many palettes already on the market I felt designing a palette with many separate color compartments for mixing and keeping colors fresh would be most helpful. Throughout the years of teaching, I have watched students who had palettes with large open, mixing areas which result in muddy colors. I wanted to help eliminate this problem.

The Martin/F Weber Company made a plastic watercolor palette that is designed to keep colors clean while including areas for mixing in wells. The 28 wells were designed to meet the needs of various painting styles. There are three styles of wells within the palette. The angled wells are used by placing the paint at the top of the well, and then mixing in the recess, this gives you precise mixing control. In the round wells around the outside edge I place pure pigment, it is easier to maintain the pigment in a pure working manner.

In the deep wells it is easy to mix large amounts of color for larger applications of paint. These can be easily rinsed at the end of the day.

The clear lid enables convenient travel and storage of the palette. When storing the paint, use the lid to guard against dust and foreign particles from getting into the paint. The lid can also be used for an additional mixing area.

For easy clean up, take a paper towel to absorb excess water or pigment. Secure the lid. When you want to resume painting, just refresh the dried colors with a brush or mist over the palette with a spray bottle.

PALETTE LAYOUT

It is far easier to establish a fixed location for each color on your palette with the colors you most often use. It's important to be consistent so you can find your colors when you want them. I prefer lining up warm colors on one side and cool colors on the opposite side. I place blues and greens in the large mixing areas as I use more of this pigment in either large sky washes or in foliage areas.

GENERAL INSTRUCTIONS

ACRYLICS

Susan Scheewe Acrylic is so versatile it can be diluted with water to make transparent washes or used with the easy to manipulate creamy consistency from the tube. You can also add various mediums that will modify the appearance and consistency.

The acrylic can be mixed with texture medium so you can build up thick layers of paint with a knife or apply with a brush.

As soon as one layer is dry, you can easily apply glazes or totally repaint an area with a second layer. When applying the pigment to a dark surface, it is a good idea to apply a layer of of **Opaque White** and allow to dry completely prior to painting a second layer of color. This step will make the second layer appear more brilliant. The glazes can be subtle transparent glazes or a less diluted more opaque glaze can quickly create depth in a painting that would take far greater time to dry using oils.

You will quickly discover how easy it is to use the Susan Scheewe Acrylics. They have been designed to be user friendly with a nice open working time. Keep a spray bottle handy to mist them lightly as you work depending on heat, wind and length of time on the palette.

After many years of working with oils I have become very allergic to many of the solvents and mediums. Using acrylics and or watercolors, I do not need to be concerned with how to dispose of the toxic solvents or of the harmful vapors.

LOOSE LEAF NOTEBOOK

Having a loose leaf notebook that you use as your personal notebook for acrylic and watercolor makes a most valuable reference. Using clear plastic three ring sleeves in the notebook to hold test paper for color charts, testing mixtures, sketches for a painting, photos as a reference and special notes.

KEEP YOUR BRUSH WET

It is extremely important to keep the brushes damp or wet as you paint with acrylics. Clean your brushes often in water and be sure to refill your water container often with fresh water. Be sure to rinse the brush under running water. Make sure the brush is clean at the ferrule as once the acrylic paint dries on the hairs it will not wash back out again. Should you be interrupted during your painting be sure to quickly place the brush in a water container until you have time to thoroughly clean them. A second container with clean water is often helpful. Don't let the last brush cleaning be the muddy water you have been using as you have been painting.

CLEAN WORKING AREA

Keep clean damp paper towels handy to wipe off any acrylic that accidently gets on the table or painting surface. It is handy to use a large plastic leaf bag to protect a surface and once the painting is completed use the bag in the yard. It is also important to protect your clothes when wearing an outfit you would not want damaged by dried paint.

TESTING COLORS

We all hate to waste paint, however testing color mixtures is a valuable aid to your painting knowledge. At the end of a painting day is a great time to label your paint mixtures on a scrap of acrylic-watercolor paper. Then you can place this in your notebook for later reference. As a general rule add just a little of the deeper value to the lighter values as you mix the colors. Start by mixing a very small sample, using a brush. Should you need a large quantity of a color, first mix a small quantity to save yourself from mixing far too much pigment.

SPONGING

The soft natural sea sponge can become one of the most versatile painting tools. Always dampen the sponge with clean water first. Then squeeze out as much water required to lift off pigment or apply pigment. Since each natural sea sponge varies you most likely will want to have several sizes and shapes.

It is very important not to allow pigment to dry in the sponge. Wash the sponge with soap and water at the completion of your painting day.

SPATTERING

The spattered appearance of pigment on a background can add the finishing touch to a painting. This technique is also wonderful to create pebbles at the beach or realistic appearance of texture on some rocks, pears and lace flowers. Diluting the pigment to an ink like consistency and placing your finger or a painting knife under the bristles that have been dipped in the diluted pigment can give more control to spatter than hitting a brush and a handle and letting the pigment fly. Have a clean paper towel handy to quickly clean up unwanted spatters.

To lift off unwanted pigment, don't press down too hard and push the pigment into the surface. A common mistake is pushing the pigment into the paper while in the rush to remove unwanted paint. If you are using watercolors you can often lift off pigment from the surface hours or weeks after it has dried. The pigment used and surface can add many varied results when lifting off color.

CORRECTING ACRYLIC

It is really easy to correct a painting using acrylics. You may want to lightly sand the surface and apply a coat of gesso or **Opaque White**. Then you could apply a second coat of pigment or several glazes. You can add layers of color to lighten or deepen.

BENCH OR FRAME

This bench is a wonderful decorative piece that can accent a room or patio for many years. It has an interchangeable panel in the back of the bench that can change with the seasons. Painting one for a child is a wonderful way to create a family heirloom, changing the panels as they grow. There is also a frame that can go around the insert piece for those having limited space. You can either paint on a panel using acrylics or cut a sheet of watercolor paper to insert. However, a piece of plastic should be cut if you are planning to use watercolor paper as a protection.

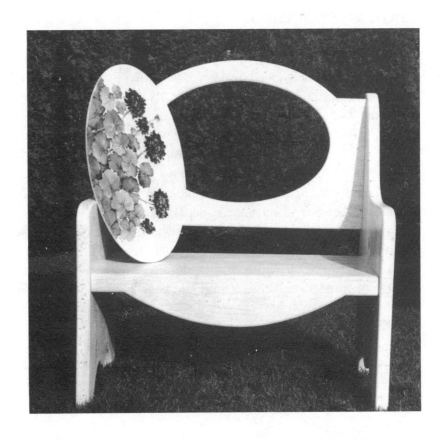

WATERCOLOR TEST PAPER

Often you will find it great to practice on a greeting card. It is much easier to experiment on something small. You can do several variations of the same scene or still life.

If you are just practicing brush strokes you could use typing paper, **BUT** don't try to do a painting on typing paper. Even the most experienced painter will have trouble with poor quality paper and especially paper not designed for watercolor.

BLUE MASKING FLUID

This is a liquid friskit which is excellent to preserve white areas in the paper. Once the frisket is applied and dried it will be waterproof but it is very important you follow the following steps when using the friskit.

1. Have a bar of soap handy.
2. Wet your No. 6 Round brush in clean water. Stroke the bristles back and forth on the soap until you have a good lather.
3. Dip carefully into the Blue Masking Fluid and paint the friskit onto the areas of your design that you want to protect.
4. Let dry thoroughly. Don't try to rush the process with a hair dryer as the dryer heat could cause the friskit to stick too tightly and damage your paper.
5. Clean your brush thoroughly as soon as you finish with it. This is a VERY important step to protect your brush.

BACKRUNS

These happen when moisture is added to a surface that has begun to dry. Try to keep the painting surface uniformly wet.

Sometimes you can go over a backrun with a clean damp brush to remove this appearance.

HOW MUCH WATER?

The amount of water you will need will come with practice. To pre-wet the surface you will want the paper to be wet enough to have a uniform shine, but not so wet that it has standing water or puddles. A puddle would be so wet if you hold the paper upright it could run. One of the popular papers has so much size on it that it puddles easily. Papers can make a great difference in how much water you will need.

The amount of moisture in the paper determines how the color will perform.

Learning to work areas to the advantage of the wet surface will make your painting fun.

Humidity can play a part in how your surface will remain damp, along with the paper surface.

300 lb. paper will stay wet and hold the moisture far longer than 140 lb. paper. This can be both an advantage or a disadvantage, depending on what you are painting.

A sponge can be helpful to pre-wet large areas. Also, a sponge can be helpful to wipe off excess water.

A hair dryer will speed the drying of the surface. This can be very helpful when you are in a hurry to speed steps along. While I do have a hair dryer in the studio I must say I seldom use it.

PRE-WET

I have found that it is often far easier to pre-wet an area before applying pigment. The pre-wet paper will allow the pigment to spread on its own where the paper has been wet. Wet by wet would bleed, to avoid bleeding work in a different area or dry with a hair dryer.

NOTEBOOK

The loose leaf format will permit you to remove specific pages for reference to solve a problem. Placing the watercolor in plastic sleeves keeps these areas clean and easy to use for personal or class-room reference. You will soon discover that this notebook becomes a valuable tool. You will include color charts, mixing, salt, special techniques and reference sketches. It is even valuable to save sections that may have been overworked as a reminder of things you don't want to repeat.

PAPER

Before you start to paint be fair to yourself and make sure you are using a good, user friendly paper. Bad paper can make a good painter look awful and just won't work. Using a paper with external sizing will make your life easier. Drawing papers are not designed for watercolor. Light weight papers ripple and buckle. I love a bargain as much as anyone, but make sure that the paper you may find on sale is really what you want.

BRUSHES

A bad brush won't work. If you have some old worn brushes you can use them for backgrounds, but do yourself a big favor and get brushes that have a good shape. If you have children that are learning to paint get them good brushes and show them how to use a brush gently.

GIFT GIVING

Do you have a friend that has everything and more time than they know what to do with? Buy them some watercolors and sign them up for painting lessons. Call your P.B.S. station and ask what time they air the series or ask them to put it on air if they currently aren't putting the show on air.

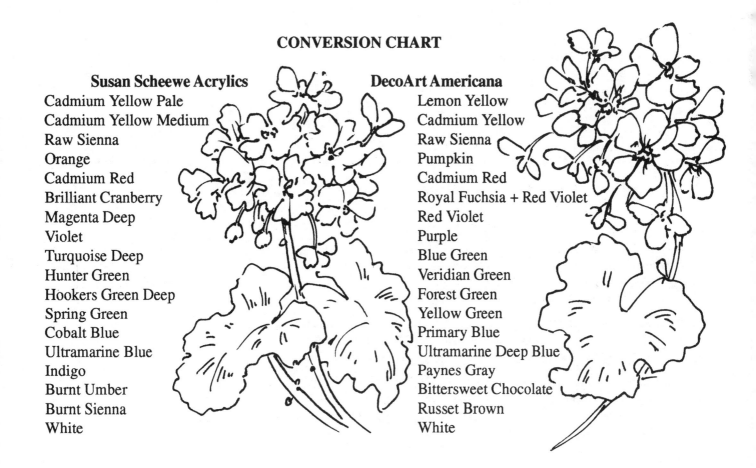

CONVERSION CHART

Susan Scheewe Acrylics	DecoArt Americana
Cadmium Yellow Pale	Lemon Yellow
Cadmium Yellow Medium	Cadmium Yellow
Raw Sienna	Raw Sienna
Orange	Pumpkin
Cadmium Red	Cadmium Red
Brilliant Cranberry	Royal Fuchsia + Red Violet
Magenta Deep	Red Violet
Violet	Purple
Turquoise Deep	Blue Green
Hunter Green	Veridian Green
Hookers Green Deep	Forest Green
Spring Green	Yellow Green
Cobalt Blue	Primary Blue
Ultramarine Blue	Ultramarine Deep Blue
Indigo	Paynes Gray
Burnt Umber	Bittersweet Chocolate
Burnt Sienna	Russet Brown
White	White

This lovely arrangement is a perfect accent for the blue room in your house.

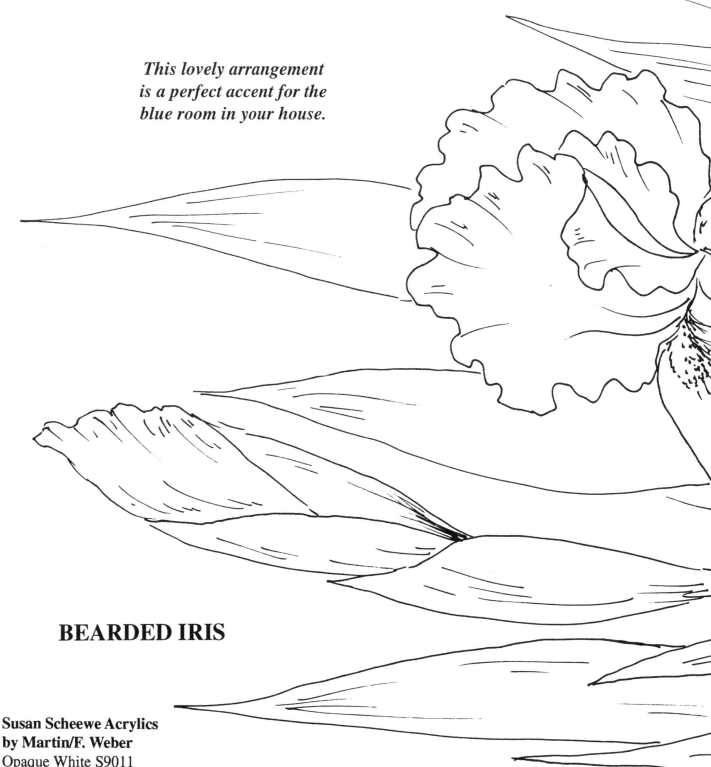

BEARDED IRIS

**Susan Scheewe Acrylics
by Martin/F. Weber**
Opaque White S9011
Cadmium Yellow Medium S9003
Cadmium Yellow Pale
Country Brick S9010
Hooker Green Deep S9004
Turquoise Deep S9007
Ultramarine Blue S9008
Violet S9009
Magenta Deep S9006
Indigo S9005

**Susan Scheewe Brushes
by Martin/F. Weber**
Series S8012 3/4 Inch Angular Shader
Series S8010 1/2 Inch Angular Shader
Series S8032 Size 0 Bristle Fan
Series S8027 1 Inch Background Angular

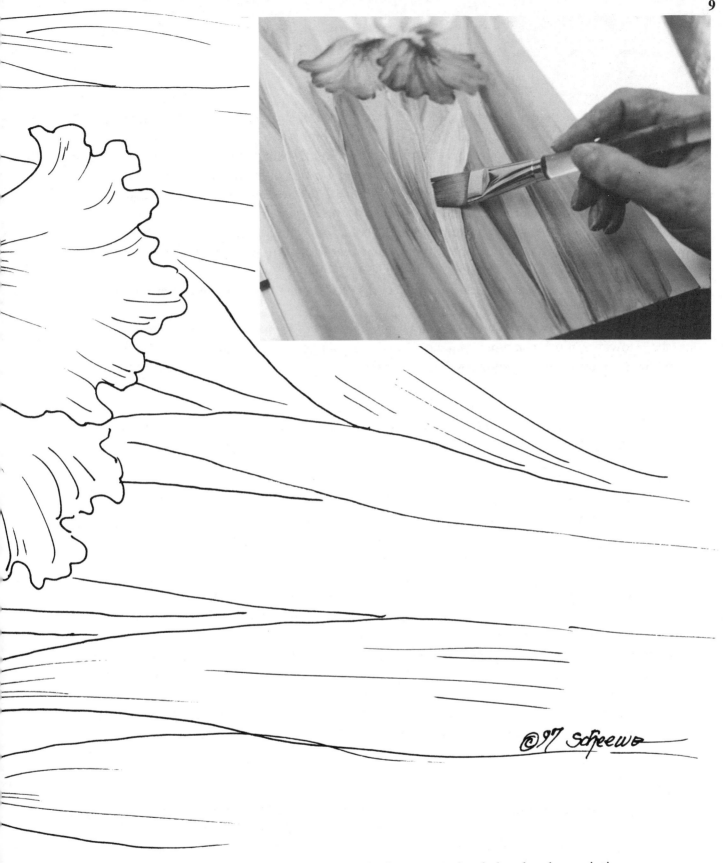

It is a good idea to keep the large spray bottle handy when painting.
You will want to spray the surface of your palette often to keep the pigment damp.
Small spray bottles are wonderful to travel with.
You can take them along to class or use them to paint outdoors.
You can also add watercolors to your small sprayer to lightly mist on color.

BEARDED IRIS

The luscious bearded iris will add a touch of elegance to any room. These delicate giant blooms are far easier to paint than you might expect. The combination of soft pastel and vibrant blue will add such dimension to the painting. Watching these blooms being painted will surely make you want to pick up a paint brush. It is wonderful to have some fresh cut iris to paint from. Make a sketch of your own. When you draw what you see you will discover and absorb many details.

The design could easily be painted as a single flower in bloom with blossoms ready to gracefully open or you could paint a panel to insert in the bench or oval. Several of the designs were painted to give you the option of many choices. Paint a large card for Mother's Day or a special occasion. You could send the card along with a mat for framing.

You can select an acrylic background to accent your room. A soft gray green or blue could be a wonderful choice.

If you are using watercolors, you will want to dampen the pigment by spraying water over the surface. However, if using acrylics, wait until you have your design prepared to paint. The following instructions are for a painting completed using acrylics.

STEP 1

Start with a light pencil sketch using a chalk pencil or transfer your painting guide on the surface using a graphite sheet. Notice how the buds are formed. Place pigments on your palette.

STEP 2

Start with the bud and then paint the petals.

Using a **3/4 Inch Angular Brush** first pick up **White** on the brush and work back and forth on the palette to get a uniform amount of pigment and then place the point of the brush in a hint of **Cadmium Yellow Medium** or **Cadmium Yellow Pale**. Place the point of the brush towards the edge of the top furthest back petal and work forward. When using watercolor you will not use **White**, but use the white of the paper. You may want to wait for one petal to dry before you do another. The brush direction is extremely important in forming the contour of each petal. There are many beautiful varieties of iris and some have very ruffled edges, while others appear only slightly ruffled. You can select to use delicate shading or a lot of contrast to add dimension to these flowers. Don't get in a rush with color. If you are not sure of the color you want, paint on a test sheet and hold it near your surface.

At the base of the upper petals, apply a hint of **Violet** on the point of the brush and paint the inside back section and lightly pull up to form more contrast from the base of each petal.

You may now want to spray your acrylic or watercolor on your palette. Keep the pigment moist.

STEP 3

Should you be painting using watercolor it would be important to paint the yellow beard in first using **Cadmium Yellow Pale** and **Cadmium Yellow Medium** tapping up and down lightly using the **Angular Shader**. Tap a shadow in on the lower section using **Country Brick**.

HOWEVER, if you are using acrylics you will want to do this step after the lower petals have been painted.

BEARDED IRIS Continued
STEP 4

As you paint the lower petals, always start with the petal that is furthest back. If you are using watercolor you may want to pre-wet the petal, this could also be done using acrylic in dry humidity where the paints dry fast. Using acrylics, wash the brush often and re-load fresh clean color. Start by picking up **White** acrylic on the **3/4 Inch Angular Brush** and then pick up a hint of **Violet** and **Ultramarine Blue** on the point of the brush. Place the point of the brush on the edge of the petal gliding the brush along the edge of the petal and then pull into the center of the flower. Watercolors dry lighter acrylics dry darker. When in doubt, start light and apply additional delicate glazes to deepen the color. Clean your brush.

Using acrylics, tap on the beard using **White, Cadmium Yellow Pale** and **Medium** and then add a hint of **Country Brick** or **Magenta Deep** towards the lower section.

STEP 5

Paint the remaining lower section of the bud using green mixtures. Use either a **1/2 or 3/4 Inch Angular Shader**. Pick up **White**, a hint of **Hookers Green Deep**, a little **Cadmium Yellow Medium** and **Pale**. Then add a touch of **Country Brick**.

STEP 6

Using the **3/4 Inch Angular Brush**, paint the graceful blades. It will be important to twist the brush as it glides upwards across the surface to form the taper. As you paint each blade, vary the height and shape. You could practice this on paper to check for color and amount of pigment desired.

First use **White** on the brush, then mix a hint of **Hookers Green Deep**, hint of **Cadmium Yellow Medium** and **Cadmium Yellow Pale**. Pull just a tiny hint of the **Ultramarine Blue** and **Violet** into the blades. A tiny occasional hint of **Country Brick** will give a realistic appearance.

Light comes forward, dark will appear more in the distance. Keep this in mind as your form each petal.

Add a few tiny touches of very diluted **Indigo** or **Turquoise Deep**.

You can use acrylics with delicate glazes or you may want to cover a blade with more pigment making them opaque. You can even add enough acrylic pigment to add texture to the surface.

STEP 7

Time to go back and add more glazes and adjust colors. Be sure to spray your palette and clean brushes often. Step back from your painting to see how the painting appears from some distance.

STEP 8

Using a **1/2 Inch Angular**, tap **Violet** just under the yellow beard and then pull down slightly following the contour of each petal. By lightly gliding the brush on the chisel you can form veins.

FINISHING

Step back again and let the pigment dry completely before you make more adjustments.

Irises come in so many colors you may want to try several variations of colors to be painted for inserts. There are bulb catalogs you could order that display many varieties.

I so enjoy hearing from you. If you send me a photo of your painting I will be delighted to return it to you.

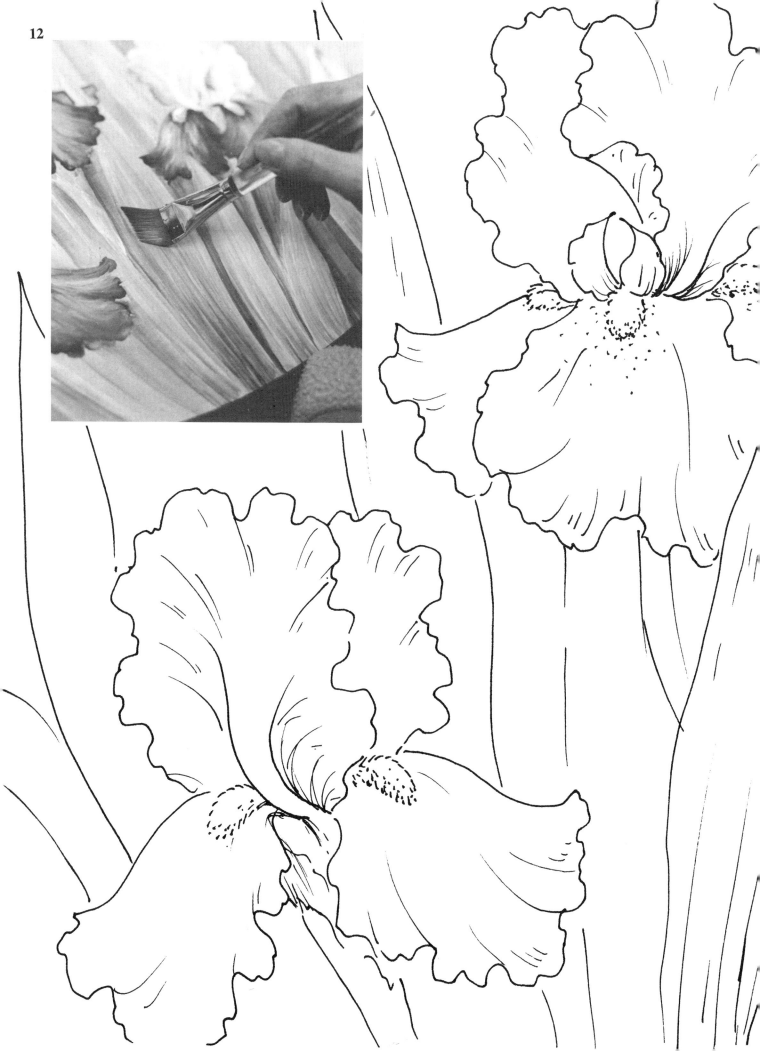

BEARDED IRIS

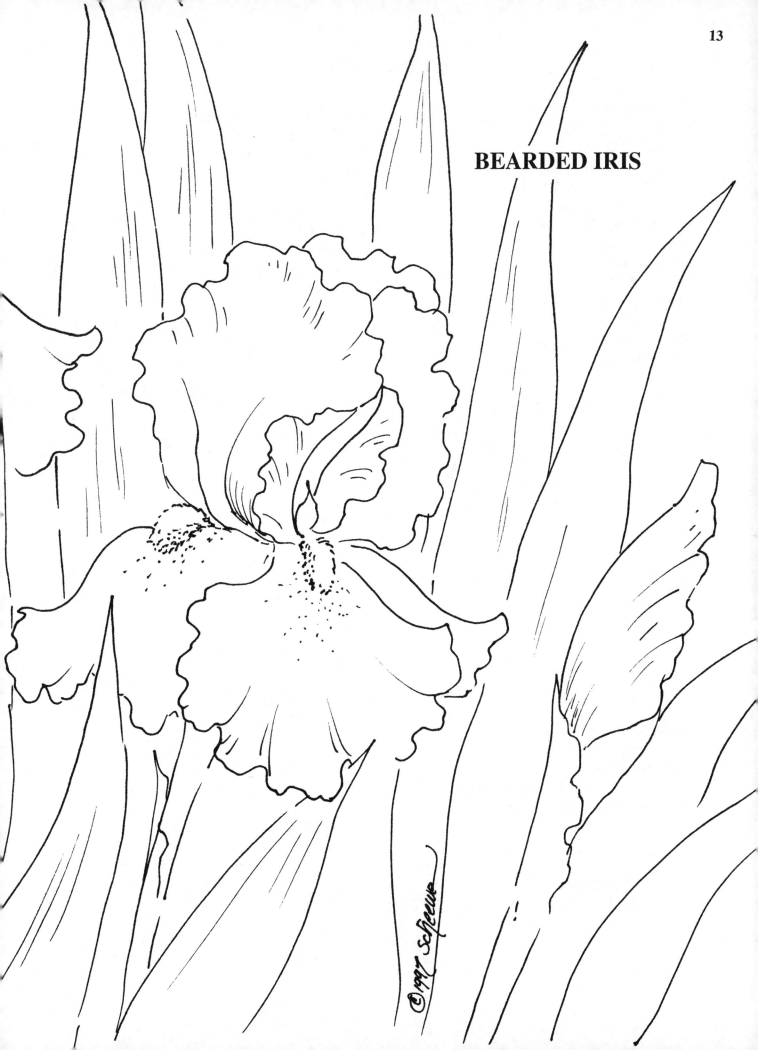

GERANIUMS

**Susan Scheewe Acrylics
by Martin/F. Weber**
Opaque White S9011
Cadmium Yellow Medium S9003
Cadmium Red Light S9002
Magenta Deep S9006
Hookers Green Deep S9004
Turquoise Deep S9007
Indigo S9005
Country Brick S9010
Ultramarine Blue S9008
Violet S9009
Alizarin Crimson S9013
Orange S9019

**Susan Scheewe Watercolors
by Martin/F. Weber**
Cadmium Yellow Medium S8412
Orange S8417
Cadmium Red Light S8403
Magenta Deep S8416
Violet S8410
Hookers Green Deep S8405
Turquoise Deep S8409
Indigo S8406

**Susan Scheewe Brushes
by Martin/F/ Weber**
Series S8010 1/2 Inch Angular Shader
Series S8012 3/4 Inch Angular Shader
Series S8032 Size 0 Bristle Fan
Series S8004 No. 5 Round

Miscellaneous
185 lb Acrylic-Watercolor Paper S9070
Objects to decorate

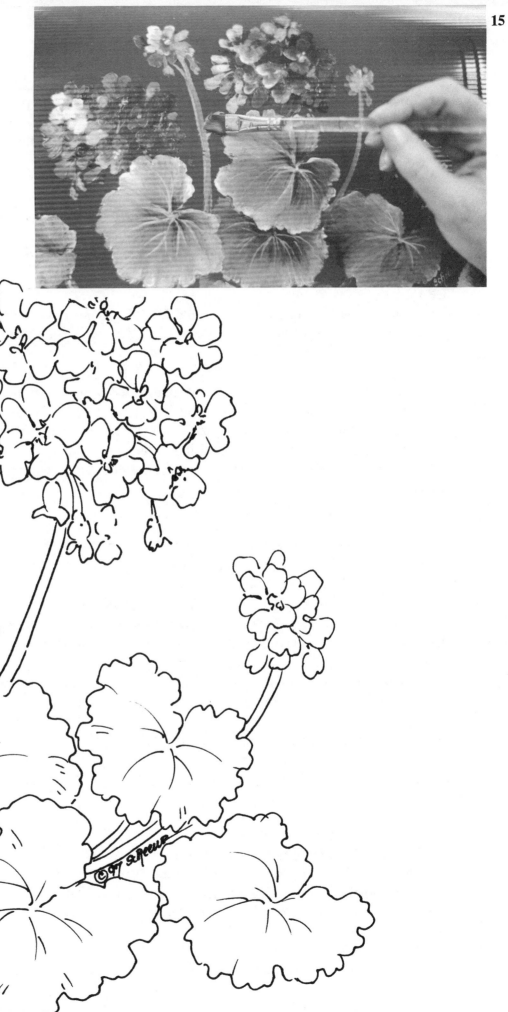

GERANIUMS

These summer favorites will brighten any room all year long. You could use watercolors to create a luscious painting using traditional techniques. Acrylics will dry permanent and could be painted on a panel that could be placed in a bench or put in a frame. I have done several of the paintings in this book using panels that can be changed during each season. Celebrate the height of summer by spending an afternoon painting these delightful flowers. These flowers are so much fun to paint, it is easy to decorate an entire patio or porch. I painted a mailbox, apple basket, watercan, birdhouse, panel and created one of my favorite watercolors. Bring in a plant as a reference as you paint or set up to paint in your own garden. Practice the flowers on an apple basket. You may want to make several sketches.

DECORATING OBJECTS WITH ACRYLIC

STEP 1

If you are using a panel you might apply White Lightening as a sealer to the surface, which also gives a white wash appearance. Allow this application to dry completely before you start to paint geraniums.

Assemble your materials, and put out your paints. If you use acrylics, put them onto your acrylic palette. You will need a container and spray bottle with clean water. Also, keep a roll of paper towels handy. Remember to rinse your brushes often. If your acrylics start to film over, spray them lightly to keep them damp. You can also but a tube of special medium which will slow down the drying process. The medium is clear, so it won't change your colors, and it will give you more blending time. Just mix some of the medium with the paint on your palette, and/or work it into your brush before you pick up your paints.

STEP 2

Start painting the flowers with a 1/2 **Inch Angular Shader** that has been rinsed in clean water. Dip into **Cadmium Red Light** and **Magenta Deep**. You won't need a lot of color, but you need to make sure it's evenly distributed on both sides of your brush.

Aim the point of your brush toward the outer edge of the flower petals. Gently pull the pigment around with a slight wiggle motion. Leaving some narrow unpainted spaces between the flower petals will look more realistic than painting a solid mass. You can also apply color where only part of a petal is visible.

While your paint has a shiny look, which means it is wet, apply touches of **Violet** or **Alizarin Crimson** on the point of your brush to give your flowers some shadows and add dimension.

Rinse your brush well, and pick up a tiny bit of **White**. Come back in and tap some centers into your flowers. This will give highlights to set off the shadows and add even more detail to your work. Acrylics dry darker, but if you think your colors are too dark, don't worry. You can always come back and lighten with another layer. Allow the bottom layers to dry before you apply another layer of pigment.

STEP 3

Use the **1/2 Inch Angular Shader**, rinse your brush thoroughly again. Use mixtures of **Cadmium Yellow Medium, Hookers Green Deep** and **Turquoise Deep** to stroke on stems and form your leaves. Put the point of the brush on the leaf's edge. Rest the flat of your brush on the surface, pulling it around with a circular motion. Then draw pigment toward the center to fill in with color. Be sure to have some areas that are light and others that are dark. Yellow shades will add "sunshine" while turquoise and violets will add shadows.

Depending on your project, you can make the surface work for you, shaping your leaves to conform to the item and setting off your leaf shapes through color contrasts.

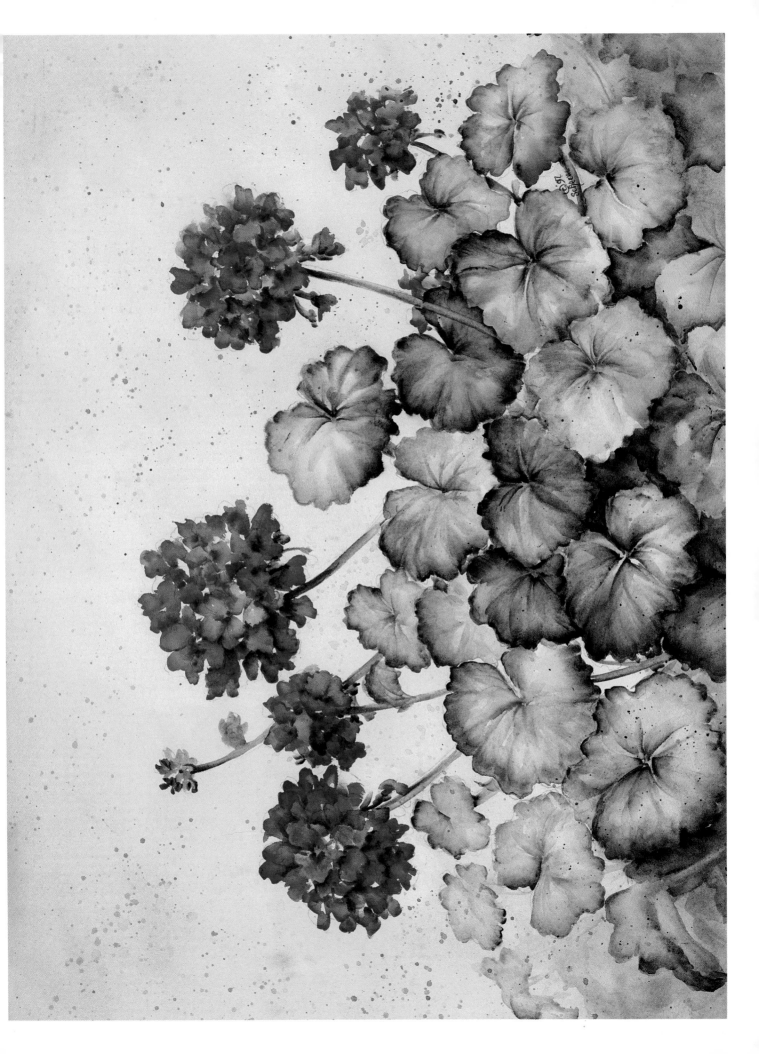

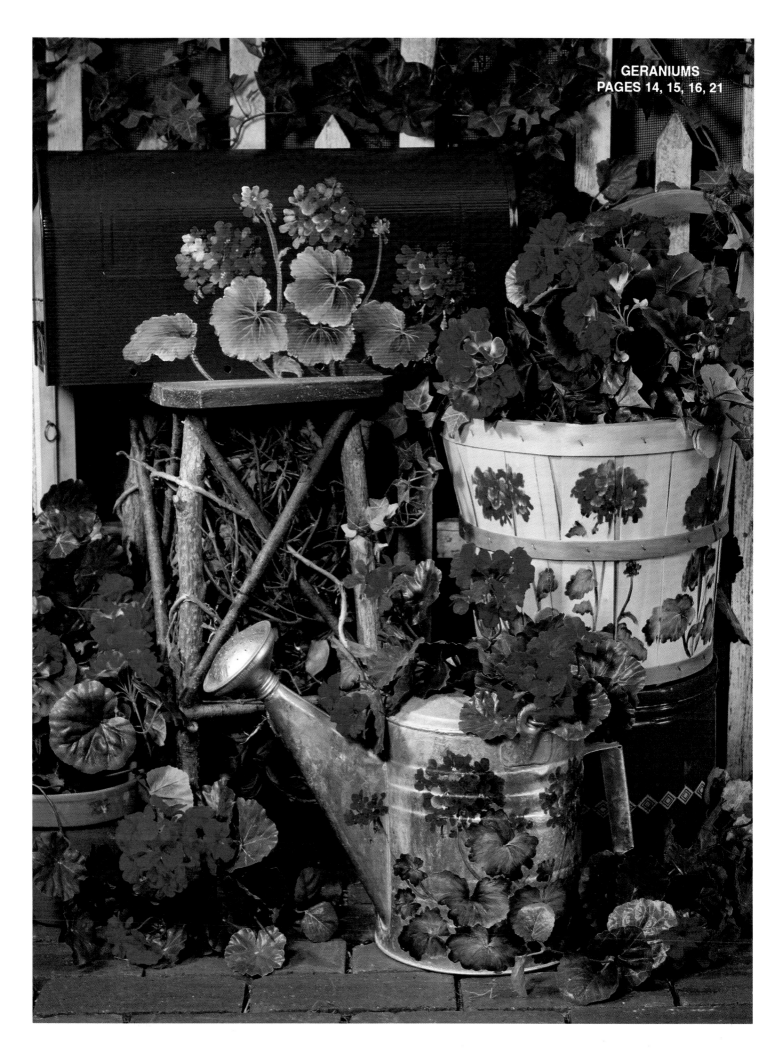

GERANIUMS
PAGES 14, 15, 16, 21

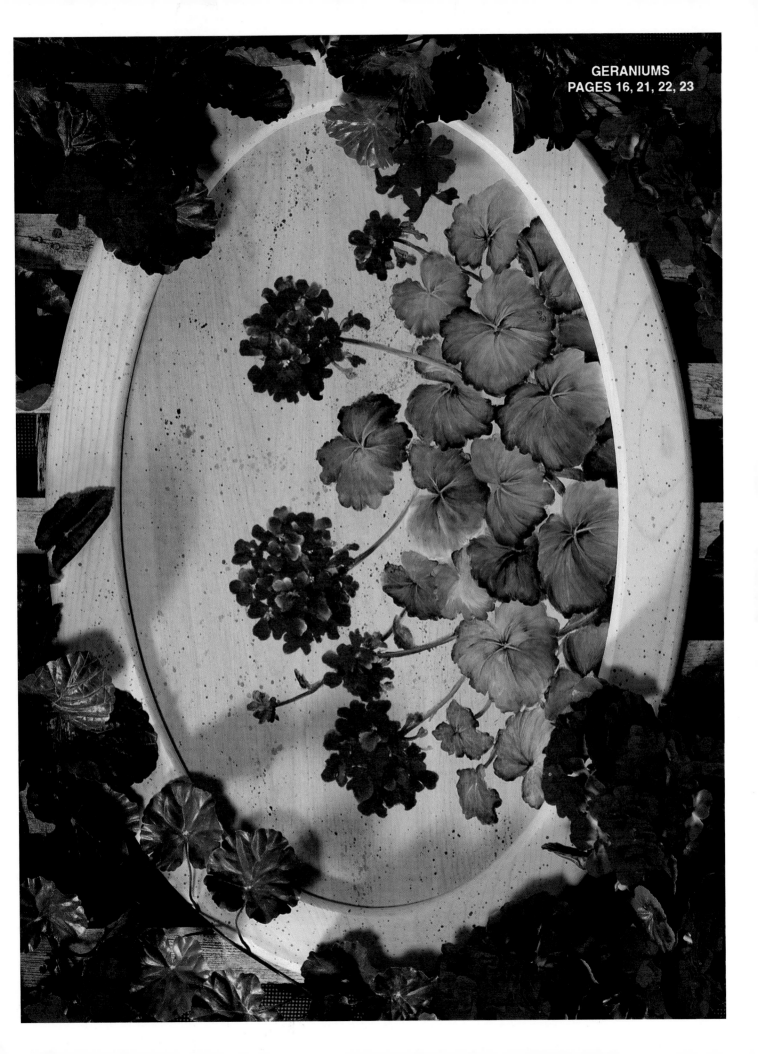

GERANIUMS
PAGES 16, 21, 22, 23

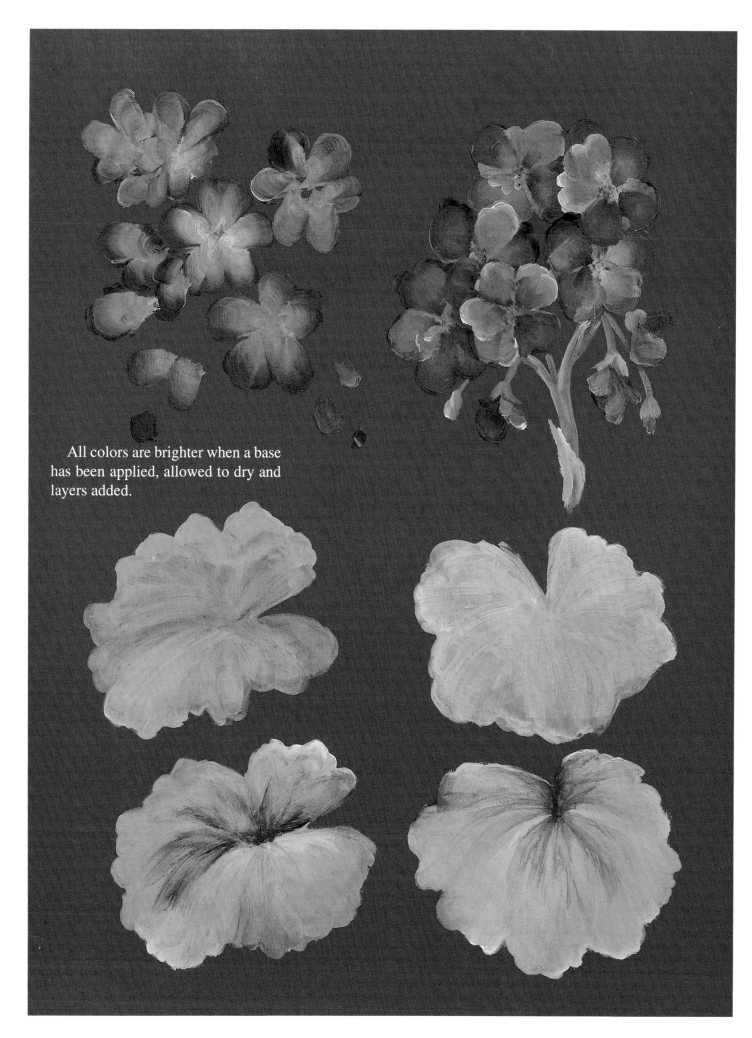

All colors are brighter when a base has been applied, allowed to dry and layers added.

STEP 4

Time to paint flower buds. Rinse your brush well. Go back to your **Cadmium Red Light** and **Magenta Deep**. Try to avoid making them look too straight and stiff.

Change to your **No. 5 Round Brush**. Dip into **Hookers Green Deep**. Stroke on tiny stems and bud pods that connect to the flowers. Look at the flowers or photo for a reference.

Apply tiny touches of **Cadmium Yellow Medium** to the pod and stem areas. Specks of yellow in the flower centers can indicate pollen, making your flowers look even more realistic.

STEP 5

Go back to your **1/2 Inch Angular Shader**. Rinse your brush well, and come back to add highlights. They will easily provide separation and create depth.

Pick up a little **White** and **Cadmium Yellow Medium**. Lightly stroke veins into the leaves. Then apply accents along the veins with **White** and **Turquoise Deep**. **Violet** can add punch as well. The deeper values will set off the veins, adding more dimension and depth.

Often you will see red values in the leaves. You may want to apply some glazes using **Magenta Deep** or hints of **Cadmium Red Light**.

FINISH

It is always an option to spatter the surface. Dilute the pigment and use a bristle brush. Have a paper towel handy to wipe unwanted paint.

PAINTING ON PAPER

You can easily use either acrylics or watercolors. I hope you will try both. You can use the same brushes, but if you switch from acrylic to watercolors, clean your brushes thoroughly.

When you use watercolors, plan ahead a few areas you may want to reserve an area for a highlight. You need not cover every part of the paper as these may serve as the sparkle of highlights. The simplest way to create paper white highlights is by painting around them or applying Blue Masking Fluid to reserve the area.

It is my hope you will enjoy painting these brilliant summer favorites as much as I do. You can even use these technique to decorate your walls. Drop me a note, I always enjoy hearing how you have used these techniques.

On my upcoming P.B.S. series I plan to paint geraniums with shades of pink on more surfaces to decorate the home. As always, I just love to paint. Enjoy.

Bench, Panels, Frames Available at:
Stan Brown Arts and Crafts
13435 N. E. Whitaker Way
Portland Or. 97230
Telephone: (503) 256-0559
Fax: (503) 252-9508
e-mail: SBrown 4207 @ aol.com

This design works well on so many items. With a metal surface, such as tin, however, you may want to sand a little so your pigment will hold better or paint a base using a metal primer.

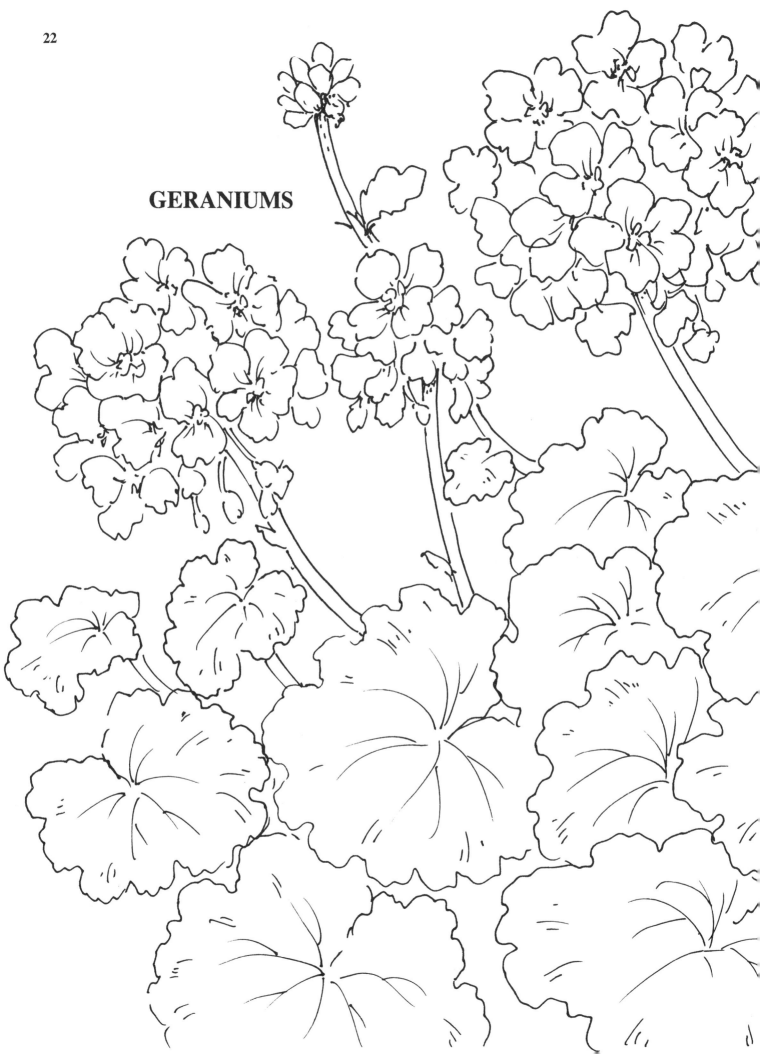

GERANIUMS

*I painted this for
my Aunt Thelma.
She always has
such a beautiful yard.
Paint this for a loved
one as a special gift.*

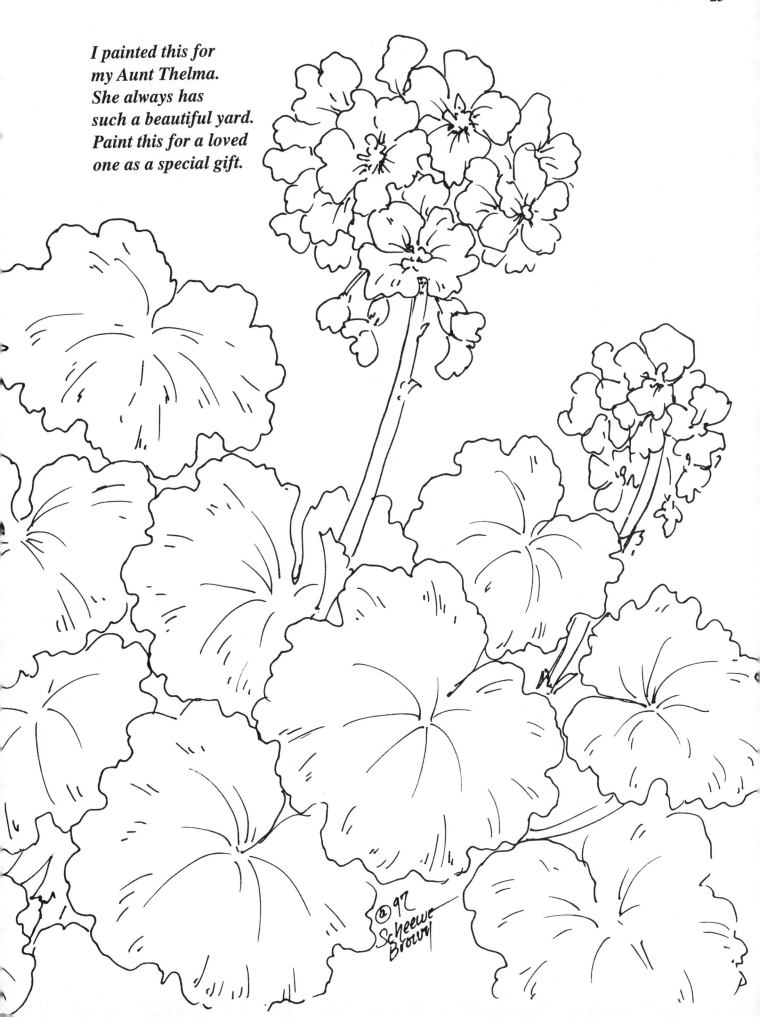

GARDEN HAT

**Susan Scheewe Acrylics
by Martin/F. Weber**
Opaque White S9011
Cadmium Yellow Medium S9003
Burnt Umber S9001
Cadmium Red Light S9002
Cadmium Yellow Pale S9015
Ultramarine Blue S9008
Turquoise Deep S9007
Violet S9009
Country Brick S9010
Hookers Green Deep S9004
Hunter Green S9017

**Susan Scheewe Watercolors
by Martin/F. Weber**
Opaque White S8407
Cadmium Yellow Medium S8413
Burnt Umber S8412
Cadmium Red Light S8403
Cadmium Yellow Pale S8404
Ultramarine Blue S8419
Turquoise Deep S8409
Violet S8410
Country Brick S8420
Hookers Green Deep S8405
Hunter Green S8415

Miscellaneous
185 lb. Acrylic/Watercolor Paper
Sea Sponge S8203
Acrylic Palette S8211

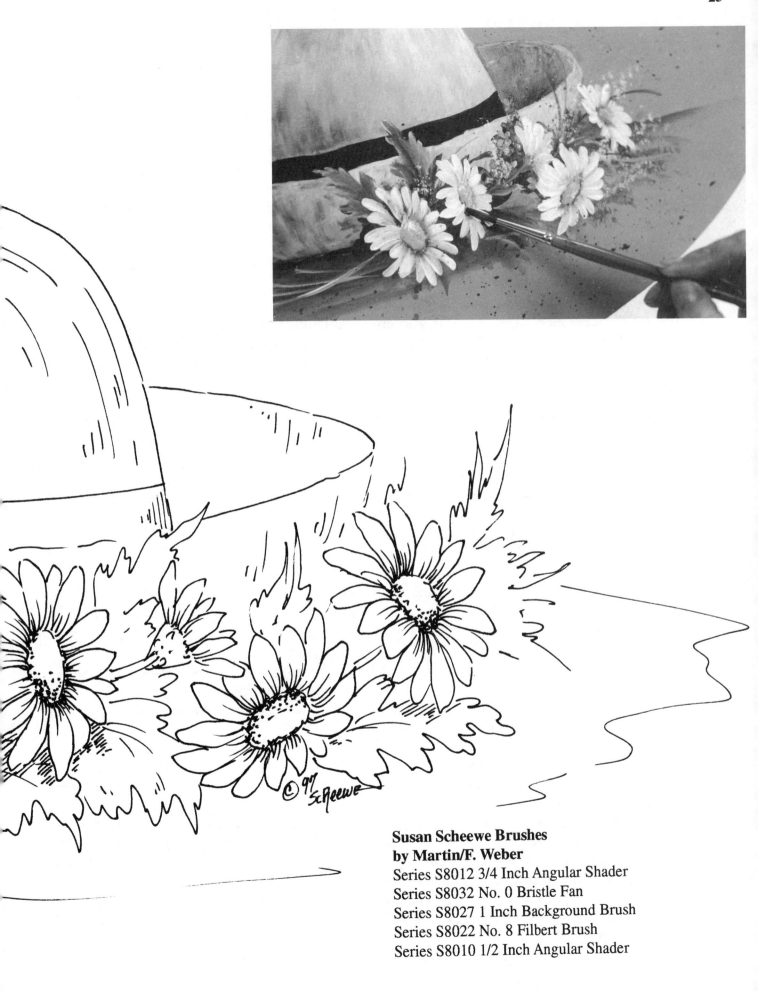

Susan Scheewe Brushes
by Martin/F. Weber
Series S8012 3/4 Inch Angular Shader
Series S8032 No. 0 Bristle Fan
Series S8027 1 Inch Background Brush
Series S8022 No. 8 Filbert Brush
Series S8010 1/2 Inch Angular Shader

GARDEN HAT

This perky garden hat would brighten any room, especially with the daisy bouquet beside it. You can do a watercolor painting or use your acrylics on canvas. You can also paint other surfaces such as a plaque or a chair. This charming painting would be fun to paint as a wonderful gift.

Should you paint an unfinished chair your first step would be to apply White Lightening to the surface. Then spatter the surface with diluted **Burnt Umber**. The insert is painted with **Country Blue**, but you could easily apply any color to accent a special room. If the color you select for a base is medium to dark in value the hat would appear brighter if you apply a basecoat of **White** acrylic, allowing it to dry completely before you start to paint. If you are on a very light surface this step would not be necessary.

I painted many of the paintings in this book to insert in the chair or the same insert could be put into a frame so the paintings can easily be changed for each season if desired. You can also cut the acrylic or watercolor paper to fit in this same shape but, you should have a piece of glass or plastic cut to protect this surface. There are many wonderful possibilities to try on these paintings.

Assemble your brushes, your watercolors on their palette and/or your acrylics on an acrylic palette. (You can do this project with either pigment or even a combination of both.) You will need a container and a spray bottle filled with clean water. Have a roll of paper towels handy.

Start with a pencil sketch or transfer the painting guide in your book. In either case, your drawing will just be a guide. How about painting your own garden hat or that of a special friend?

STEP 1

If you use watercolors, mist them lightly with clean water just before you start to paint. If you use acrylics and they have been out for awhile, you may want to mist them to slow the drying process. As you paint, rinse your brushes often, especially if you are working with acrylics, since dried acrylic will ruin your bristles. Keep a good amount of clean water available.

STEP 2

Before you begin, decide what direction sunshine will come from in your painting. I have my light source on the right hand side of my work, so the areas facing that side will be the brightest. The spaces on the side of the painting that is away from the light (the left side of my painting), will have deeper values and a more shadowed look.

The hat crown gets the light first, so start where the crown will be the brightest. Use your **3/4 Inch Angular Shader**. To load your brush, hold it so your bristles are at an angle and pick up paint with just the brush point. Having your brush at an angle helps you load the paint easily so that your color variations blend across the area you are painting.

If you are using watercolors you will want to leave some paper white for a highlight on the top right section of the hat crown, but if you are using acrylics you can paint the highlight in the area.

Think about the brush direction as you apply the pigment, as this will form the contour of the crown. Pre-wet the crown with clean water.

Remember to keep some paper white as you apply **Cadmium Yellow Pale** starting on the right side of the crown. Sweep the strokes with a light touch of the brush allowing some streaks to appear.

Deepen the value as you work toward the left side of the crown by adding **Cadmium Yellow Medium, Country Brick** and a little **Burnt Umber**. Do not overblend. By deliberately leaving streaks of color, the hat will appear more realistic. Acrylics dry darker and watercolor dries lighter, so you may wait until the pigment dries to make some adjustments. Most important is that you like the color you have painted the hat.

GARDEN HAT Continued
STEP 3

Paint the inner part of the hat brim on the left side. Using a hat for a model is helpful as you would see the light and shadow areas as you paint. The sunlight hits on the left section and will be brighter. Apply **Cadmium Yellow Pale** to this area using a **3/4** or **1/2 Inch Angular Shader**. Refer to the photo. Pick up a little **Burnt Umber** and **Country Brick** on the point of the angular shader, place the point of the brush at the bottom section and pull the darker section back and forth to form a nice gradation of color.

The inner part of the brim in front of the crown will be in shadow. Paint this area with a mixture of **Cadmium Yellow Medium, White** and **Burnt Umber**. If you feel that any part of the painting is too dark and you have used watercolor, you can always rinse your brush in clean water, dab off the excess, go back to your painting and lift off pigment. If you are using acrylic, you can simply stroke on a little **White**.

STEP 4

I painted my hat band with a mixture of **Violet** and **Burnt Umber**, but use any color you like. (Perhaps you could make the ribbon a shade that matches or compliments the decor of the room where you will put your painting.) Allow some gradations of color here as well.

If you use acrylics and accidentally get some paint on the leaf and flower areas, you can come back later and paint over them. If you use watercolors, however, you might want to apply **Blue Masking Fluid** to protect those surfaces while you paint the band. Be sure to protect your brush with soap before using **Blue Masking Fluid**. A **5** or **6 Round Brush** makes excellent daisy petals.

STEP 5

Using a **3/4 Inch Angular Shader** paint the forward part of the hat brim. Think about the contour of the hat as you apply pigment. Start by applying a little **Cadmium Yellow Medium** and then deepen the value with just a little **Burnt Umber**, a hint of **Country Brick** and **Violet**. The value is lighter on the front outer brim that is closest to the light source. Pull the brush around with a light sweeping motion to help shape the contour.

Work carefully behind your daisies and leaf shapes, putting the deepest values along the edges of the flowers and leaves where there would be a cast shadow. Pick up a little **Violet** and **Burnt Umber** on the point of the angular shader and apply glazes of color. Add enough water to create a gradation of color. Be careful not to leave a hard outline.

STEP 6

Next paint the lower background section.

Change to a larger background brush but, be sure the brushes you just used are completely clean. Use either a **1** or **1-1/2 Inch Background Brush** and apply clean water to the area along the sides of the hat and in the foreground until you see an even shine.

Apply diluted **Violet** and **Ultramarine Blue** to the point of the brush and apply, starting at the left section next to the bottom of the hat. Come up on the sides of the hat as well to make the appearance of sitting on something. Apply the pigment with an uneven shadow to create a more interesting appearance. For the brave, you can wet the surface until the water is running and apply pigment, allow the flow of the pigment to form wonderful reflections. Touches of yellows can even be added. If you aren't sure what you want to do, try this technique on scrap paper first.

GARDEN HAT Continued

STEP 7

The top section of the background is painted next. Pre-wet the background area above the hat using clean water. **Turquoise Deep** is a very strong pigment so, you will want to dilute this with a lot of water. While the surface is wet, apply **Turquoise Deep** with a little **Ultramarine Blue**. Start next to the hat and allow the pigment to diffuse out. You may want to change the angle of the paper to allow the pigment to diffuse in a desired direction. To add sunshine, drop in some hints of **Cadmium Yellow Light** along the top of the painting.

STEP 8

Spattering gives a nice effect and adds another dimension to your work. If you'd like to use the spattering technique here, dip your **No. 0 Fan Brush** into diluted pigment and hold you index finger over your work. Flick the bristles against your fingertip, spreading small spots of pigment across your painting. If you spatter too heavily, you can dab off excess with a paper towel. Use diluted **Turquoise Deep** and **Violet**.

STEP 9

Change to your **3/4 Inch Angular Shader** and a mixture of **Hookers Green Deep, Cadmium Yellow Medium, Cadmium Yellow Pale, Turquoise Deep** and **Ultramarine Blue**. Lightly tap on the leaves. Allow variations in color. Yellow adds sunshine and hints of violet will accent shadow areas. (**HINT:** If the leaves don't show up as well as you'd like against the dark hat band, you can come back later and add another layer.)

Stroke on some leaf stems and grass blades.

Contrast is very important. Apply more pigment on the point of the brush. You can paint just a suggestion of greens behind the daisies or you can always come back and refine these areas.

STEP 10

Time to paint the daisy petals.

Change to your **No. 8 Filbert Brush** and **Opaque White** if you are using acrylics. Make sure your background is completely dry if you are using watercolor before you remove the **Blue Masking Fluid** to reveal the paper white petals.

Using acrylic, apply **Opaque White** to form the petal shapes using a round brush or filbert. Having a little damp color behind the petals will add dimension to the petals but, color can also be glazes on top of the petals. Using diluted **Violet, Ultramarine Blue** and hints of green.

STEP 11

Paint the center area of the flowers next. Apply **Cadmium Yellow Pale** to the entire center area. Pick up a little **Cadmium Yellow Medium** on the point of the brush and start to form a deeper value next to the petals to form contour. Add hints of **Cadmium Red Light** mixed with **Cadmium Yellow Medium** to deepen the value and without cleaning the brush pick up a little **Country Brick** and a hint of **Burnt Umber**. Clean your brush.

A few taps of **Opaque White** for a highlight will add the finishing touches.

FINISH

Stand back from our painting and look to see if you need a few adjustments. Often a second layer of **White** on the tips of some of the daisy petals adds dimension. Don't do each petal or they all will appear the same.

Adding little shadow areas by glazing on diluted **Violet** and **Burnt Umber** can create contrast if needed.

SPRING INTO ACRYLIC

**Susan Scheewe Acrylics
by Martin/F. Weber**
Opaque White S9011
Magenta Deep S9006
Violet S9009
Ultramarine Blue S9008
Turquoise Deep S9007
Hookers Green Deep S9004
Cadmium Yellow Medium S9003
Mars Black S9012

**Susan Scheewe Brushes
by Martin/F. Weber**
Series S8028 1-1/2 Inch Background Angular
Series S8004 No. 5 Round
Series S8038 1Inch Foliage Brush
Series S8011 5/8 Inch Angular Shader
Series S8022 No. 8 Filbert

MISCELLANEOUS SUPPLIES
185 lb. Cold Press Acrylic-Watercolor Paper
11 x 14 Stretch Canvas
Graphite S8205
Spray Bottle S8201

We created the acrylic line to compliment the Martin/F. Weber Sue Scheewe Watercolor line. There are many paintings in the upcoming Scheewe Art Workshop on your Public Broadcasting Stations that I will do in both watercolor and acrylics. There will be some used for mixed media. This project will give you an opportunity to try the feel of the paint. The creamy consistency is made using much the same pigments used in our watercolors so you can do them in either watercolor or acrylic.

This particular project is great for beginners because it gives beautiful results, but it's not over challenging. It also gives you a feel for acrylics, showing how you can use them both on paper as you would watercolors or as acrylics on canvas. I want projects like this to show you can do a lot of different things with your paints and to get you thinking of projects as a springboard for your ideas. You could paint this project on canvas or the new acrylic watercolor paper.

Make a light sketch of the butterflies and poppy shapes or transfer the large butterflies and poppy shapes to your surface so you will have visual placement. Once you decide where you want them, you can drop in the small flowers, grass blades, butterflies and poppies freehand.

Place your acrylics on your palette, but have a spray bottle handy to lightly spray the surface if the paint has started to dry. Should you use watercolors to do these paintings, spray your palette. Do not put acrylic on your watercolor palette.

On the television program I used the acrylics much like I used my watercolors on paper, but you could use acrylics on a stretched canvas.

ON WATERCOLOR PAPER

STEP 1
For this painting, I will start with acrylics, but you could begin the same way with watercolors. Begin with the sky area, carefully bringing the color behind your flowers. Pre-wet the paper with your **1 Inch Angular Background Brush** and clean water until the surface has a nice, even shine. This will make your paints diffuse evenly.

Dip into **Ultramarine Blue** and a touch of **Turquoise Deep**. Starting in the upper left hand corner, working toward the center, glide the paint lightly onto your paper, working carefully around the butterflies and poppies. Remember acrylics will always dry a little darker than they look when they are wet, so start with a bit of pigment and work for a nice gradation of color. Allow to dry.

SPRING INTO ACRYLIC Continued

ON WATERCOLOR PAPER Continued

STEP 2

It's fun and easy to create the background filler flowers. Use your **1 Inch Background Brush** to pre-wet the background so the colors will diffuse on your paper.

Change to your **3/4** or **1 Inch Foliage Brush**. Apply variations of mixtures of **Ultramarine Blue, Turquoise Deep** and hints of **Violet**. Tap the brush lightly up and down. Vary the height and shapes to give the impression of flower clusters in the background. You will get a lovely watercolor effect that is soft and out of focus. Allow the paper to dry to form a sharper edge on the flowers.

STEP 3

Begin painting your butterflies, starting with the larger shape and then doing the smaller ones. With your **5/8 Inch Angular Shader**, stroke on **Cadmium Yellow Medium**. You can get variations just by adding water. (Less water will give an opaque effect, or adding water will give a more delicate look.)

Pick up a little **Magenta Deep** on the point of your brush and apply it, keeping the point of your brush toward the outer edges of your butterflies. This gives a nice burnt orange accent.

STEP 4

Now you need to add some stems and blades of grass. I like to use my **1/2 Inch Angular Shader**, but you can use a **No. 5 Round Brush** just as well. Pick up a little **Cadmium Yellow Medium** and a bit of **Hookers Green Deep**. Start in the area below your poppies. If you choose the angular brush, use the chisel edge on your brush. Glide, twist and pull lightly from the background flowers up toward the flower heads. If you prefer the round brush, use the same colors and pull your brush tip up toward the flower heads. A good technique as well with the round brush is to balance your hand by placing your little finger against the canvas for support.

You can create grass blades using the same kind of light, curving strokes with **Cadmium Yellow Medium, Hookers Green Deep** and a little bit of **Black**. (If you're doing a watercolor painting, you will need to use **Indigo**.) Your grass blades will look more natural if you vary their placement, length and color.

STEP 5

Paint your poppies. These pretty ruffled flowers will look like they are leaning into the wind. (**HINT**: Practice makes perfect and you can get in some very good practice doing greeting cards with this design for your family and friends.)

Begin with your **5/8 Inch Angular Shader**. Pick up a little **Magenta Deep** and **Violet** on the other side. Add a little water to get the more transparent look of watercolor. Put the whole surface of the brush down on your design with the point of your brush toward the outer edge of the flower. With a slight wiggle motion, pull the point of your brush along, letting the darker color flow along the upper edges of the flower to create a ruffled look. Pull your pigment down and around toward the poppy's center and lower edges.

STEP 6

With your **No. 5 Round Brush**, outline and section the butterfly wings, with **Black**. (If you were doing this painting with watercolors, you would use **Indigo**.) Also the lower edge of your butterflies, lightly stroke on thin lines for their bodies and the antennae.

Finally, you can add accents with a few **White** dots on the wings.

SPRING INTO ACRYLIC Continued

ON STRETCHED CANVAS

STEP 1

To color the sky area, begin with your **1 Inch Foliage Brush** and a mixture of **Opaque White**, **Ultramarine Blue** and a little **Turquoise Deep**. Don't pre-wet the canvas. Just stroke on the pigment, starting in the upper left corner, pulling the paint downward toward center around the poppies and butterflies, lighten in the center area with more **White**. Don't worry if you accidentally cover up part of your design. Acrylics are opaque, but they dry very quickly. If you need to, you can even paint your background, allow the surface to dry and sketch your design over the top of it. You could always add a few variations of background colors, remember this is your painting.

STEP 2

To paint the background filler flowers, change to you **1 Inch Foliage Brush**. Apply variations of mixtures in **Ultramarine Blue**, **Turquoise Deep** and hints of **Violet**. Tap the brush lightly up and down. Vary the height and shapes to give the impression of flower clusters in the background. Add pigment to intensify the values. Let the paint dry. The amount of water added to your brush will make this brush form different results.

STEP 3

Begin painting your butterflies, starting with the large shape and then doing the smaller ones. With your **5/8 Inch Angular Shader**, pick up **Cadmium Yellow Medium** and a little **White**. You will paint the entire shape, providing a foundation for other pigment that you will apply later.

Pick up a little **Magenta Deep** on the point of your brush and apply it, keeping the point of your brush toward the outer edges of your butterflies. The result will be a nice burnt orange accent on the wings.

(**HINT**: If you want to change your mind about the colors of your butterflies, you can do so very easily with acrylic. Just stroke some **White** over the top, let it dry and apply whatever color you want.)

STEP 4

Start painting your poppies. These pretty ruffled flowers will look like they are leaning into the wind. (**HINT**: Practice makes perfect and you can get in some very good practice doing greeting cards with this design for your family and friends.)

Begin with your **5/8 Inch Angular Shader**. Pick up **White** on one side of the brush and a little **Magenta Deep** and **Violet** on the other. Put the whole surface of the brush down on your design with the point of your brush toward the outer edge of the flower. With a slight wiggle motion, pull the point of your brush along, letting the darker color flow along the upper edges of the flower to create a ruffled look. Pull your pigment down and around toward the poppy's center and lower edges. You can apply some darker shades for contrast.

STEP 5

Now you need to add some stems and blades of grass. You can use either your **1/2 Inch Angular Shader** or your **No. 5 Round Brush**. Pick up a little **Cadmium Yellow Medium** and a bit of **Hookers Green Deep**. Start in the area below your poppies. If you choose the angular brush, use the chisel edge of your brush. Glide, twist and pull lightly from the background flowers up toward the flower heads. If you prefer the round brush, use the same colors and pull your brush tip up toward the flower heads. A good technique as well with the round brush is to balance your hand by placing your

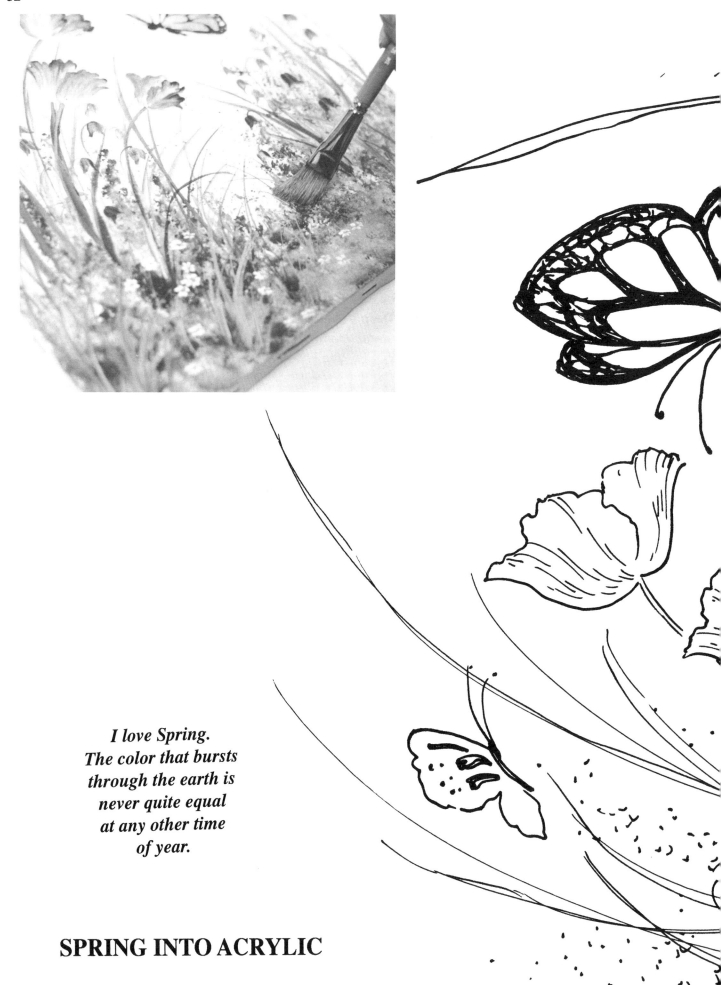

I love Spring.
The color that bursts
through the earth is
never quite equal
at any other time
of year.

SPRING INTO ACRYLIC

SPRING INTO ACRYLICS Continued

ON STRETCHED CANVAS Continued

little finger against the canvas for support.

 You can create grass blades using the same kind of strokes with **Cadmium Yellow Medium**, **Hookers Green Deep** and a little bit of **Black** or **Indigo**. The blades will look more natural if you vary their placement, length and color.

STEP 6

 Outline and section the butterfly wings with your **No. 5 Round Brush** and **Black** or **Indigo**. Along the lower edge of your butterflies, lightly stroke on thin lines for their bodies and the antennae. Finally, you can add accents with a few **White** dots on the wings.

SUSAN SCHEEWE WATERCOLOR SEMINARS

 Join in the excitement of learning more about watercolors. You can take a week for water-color training for your painting pleasure or you can become a Susan Scheewe Certified Instructor.

 Classes are held in Portland, Oregon and across the United States. Write or call for information and schedules. Scheewe Publications Inc. / 13435 N.E. Whitaker Way / Portland, Or. 97230

 PH (503)254-9100 FAX (503)252-9508

 SCHEEWEPUB@aol.com Suescheewe@aol.com

N.W. WATERCOLOR SEMINAR - A fun filled week long seminar in the beautiful N.W., each Summer / Fall. The seminar will be conducted both in the studio and on location in the picturesque Pacific N.W. Guaranteed to be a great time for all.

PRIMARY LEVEL SEMINAR- Is an introduction to watercolors. Emphasis will be on understanding the many techniques used in completing a watercolor painting. The importance of understanding the variety of surfaces will be included as painted samples are being completed. As the participants work on samples for their notebook they will learn the skills which will be applied to class paintings which will be com-pleted during the training session.

SECONDARY LEVEL SEMINAR- This session will emphasize techniques and more advanced projects. Projects will be completed for make-it take-it promotions, demonstrations, and teaching skills. Learn the tools to make corrections as you create more advanced paintings.

CERTIFICATION LEVEL- This is the exciting step to complete the certification series. More advanced projects will be painted. Sharpening the teaching skills will be stressed. We will discuss promotion, class set up, product sourcing and other valuable information for Scheewe Instructors.

Call your local PBS Station to find out day and time for the Scheewe Art Workshop

𝒫aint along with Susan Scheewe, TV's popular artist.

"I believe with all my heart that anyone who wants to paint can paint"

Martin/F. Weber Co.
Philadelphia, PA 19154 USA
Made in USA

WEBER

Wonderful rainy day gifts. You may purchase a set of videos from each of the P.B.S. Art Workshop series. The series are composed of 13 half hour shows. There are additional video tapes with a variety of subject matter and length. These tapes can be purchased through:
Scheewe Publications Inc.
13435 N.E. Whitaker Way Portland, Or. 97230
PH (503)254-9100 FAX (503)252-9508

Scheewe Art Books Workshop Series
Books and Videos

All Scheewe Art workshop Series Videos are 13 - 1/2 Hour
Shows on 4 Videos

*Scheewe Art Workshop I - S8225	Videos $69.99
Introduction to Watercolors - #314	Book $11.95
*Scheewe Art Workshop II - S8223	Videos $69.99
Watercolors Anyone Can Paint - #325	Book $11.95
* Scheewe Art Workshop IIIA - S8375	Videos $69.99
The Garden Scene - #339	Book $11.95
*Scheewe Art Workshop IIIB - S8376	Videos $69.99
Watercolor Landscapes - #360	Book $11.95
*Scheewe Art Workshop IIIC - S8377	Videos $69.99
Garden Treasures - #361	Book $11.95
*Scheewe Art Workshop IIID - S8378	Videos $69.99
Watercolor Collection - #374	Book $11.95
*Scheewe Art Workshop IVA - S8384	Videos $69.99
Scheewe Art Workshop - Watercolor & Acrylic - #398 Book $11.95	
*Scheewe Art Workshop IVB - S8385	Videos $69.99
Enjoy Watercolor & Acrylic - #399	Book $11.95
*Scheewe Art Workshop IVC - S8386	Videos $69.99
Le Jardin - #414	Book $12.95
*Scheewe Art Workshop IVD - S8387	Videos $69.99
Simply Acrylic & Watercolor - #418	Book $12.95

POSTAGE $4.00 per tape
$2.50 1st book packing & shipping
$1.50 per additional books

ELEGANT BASKET

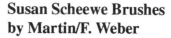

Susan Scheewe Acrylics
by Martin/F. Weber
Opaque White S9011
Cadmium Yellow Medium S9003
Cadmium Red Light S9002
Magenta Deep S9006
Indigo S9005
Hookers Green Deep S9004
Ultramarine Blue S9008
Violet S9009

Turquoise Deep S9007

Susan Scheewe Brushes
by Martin/F. Weber
Series S8037 3/4 Inch Foliage Brush
Series S8010 1/2 Inch Angular Shader
Series S8013 1 Inch Angular Shader
Series S8017 No. 1 Liner
MISCELLANEOUS SUPPLIES
Cotton Swab
Texture Medium S8206
Texture Tip S8209

Delicate flowers are tapped on the surface so easily, this bouquet will surely encourage you to get out your paint brushes.

The texture medium not only adds dimension to the surface, it adds a touch of elegance. A perfect gift to paint for members of a wedding party, as the colors selected can so easily be designed so each member will receive their favorite colors. Use this same technique to paint greeting cards for thank you gifts, birthdays or invitations.

You can transfer a painting guide or freehand the design, allowing diffused pigment to stir you creativity. You may want to plan your placement of the berries.

STEP 1

Pre-wet the background using a **1-1/2 Inch Background Brush**. Wet the surface of the paper until you see a shine. You will place on the wet surface the pigment which will dilute easily and create a soft background appearance. Dilute the color of your choice to tap on flowers. The amount of moisture on the surface along with paper can create variations. Using the **3/4 Inch Foliage Brush**, lightly tap pigment in the flower area. Should your paper start to dry, dampen the surface again. You can easily tap on more pigment. Think about making an interesting shape. Clean your brush completely when using acrylics.

If you are painting this on a wood surface you can easily use the same technique, however you will want to use a little more pigment and add **White** to the mixture.

Be careful not to pound the surface too hard.

STEP 2

Pre-wet the shape of the container. It is really fun to do many variations as this is such an easily painted project.

Pick up more pigment on the point of the **1 Inch Angular** and glide this at the left edge of the container allowing the pigment to flow and diffuse back towards the center. Place pigment on the right side and along the bottom.

When painting this on a wood surface, you might first lightly dampen the surface with water and then apply a mixture of your favorite color and **White** to form the container, adding more **White** to the center and slightly to the right of the center. Make sure to rinse and clean your brushes often as acrylic can damage a brush if allowed to dry.

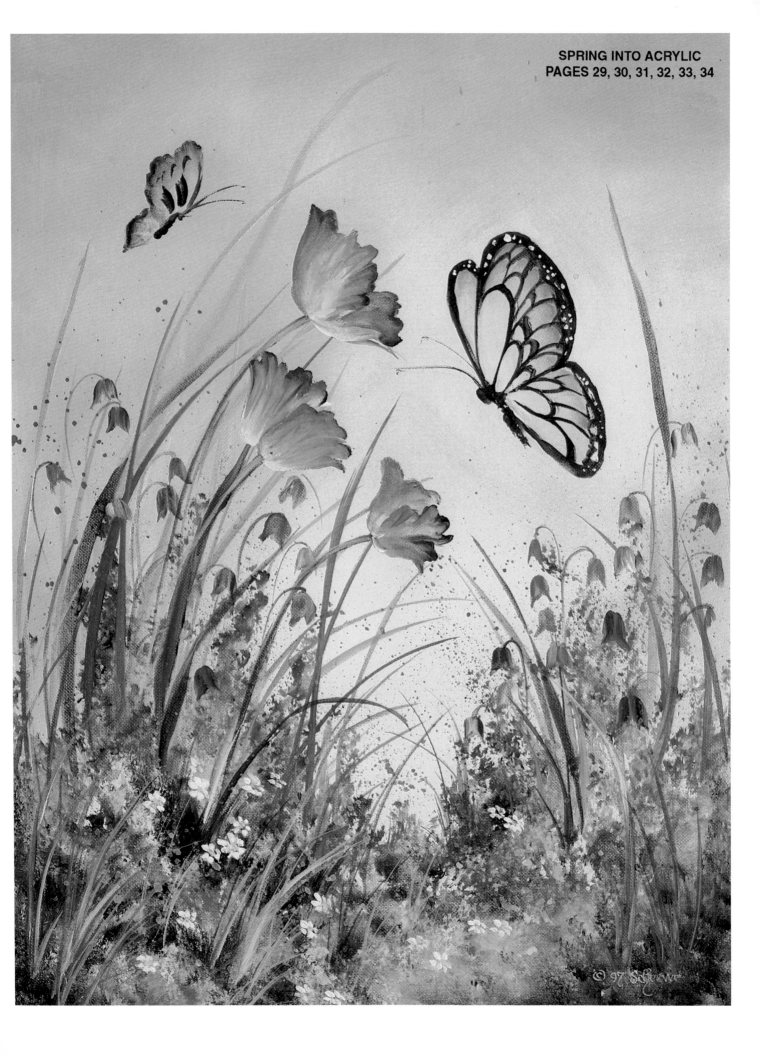

© 97 Scheewe

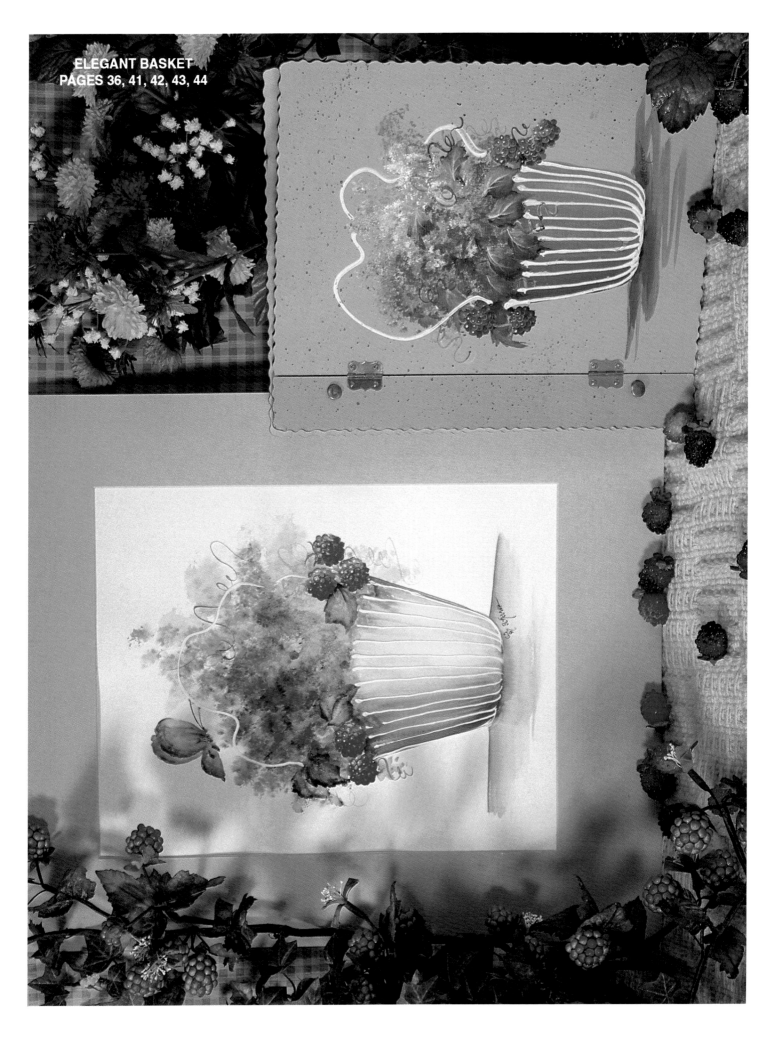

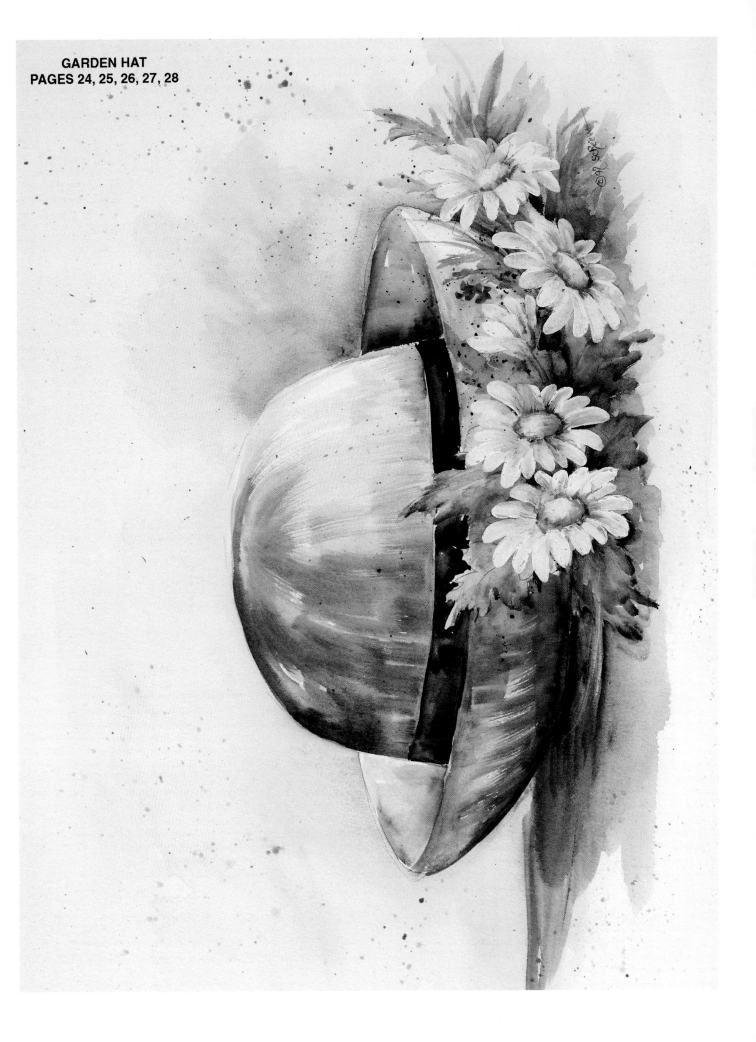

GARDEN HAT
PAGES 24, 25, 26, 27, 28

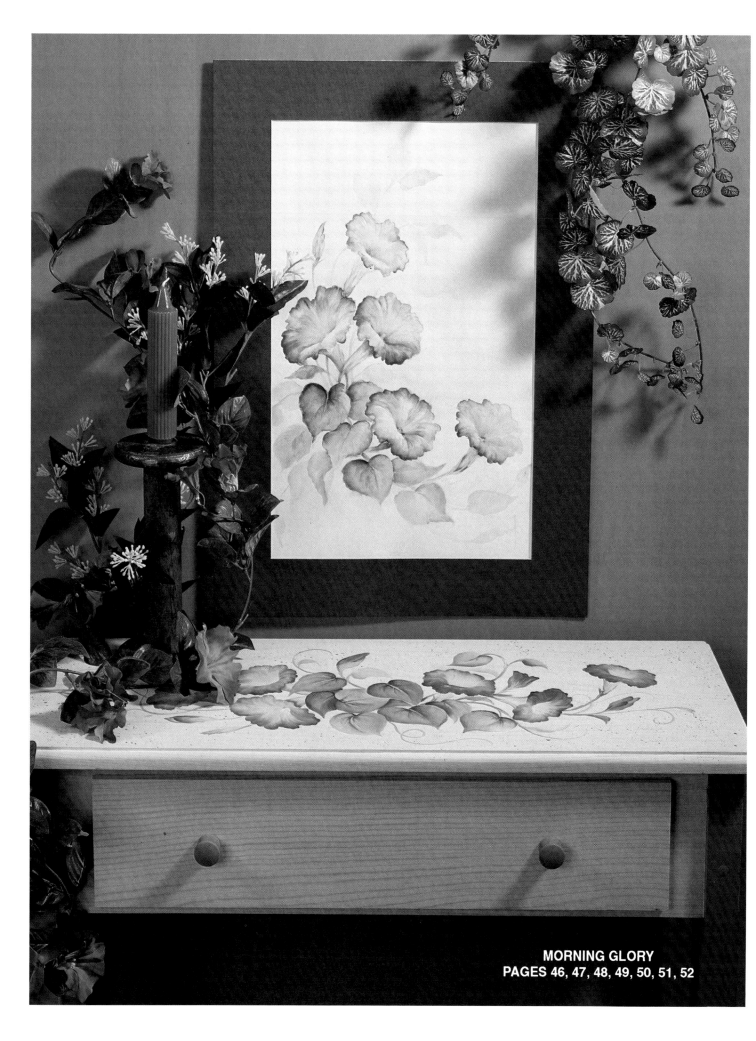

MORNING GLORY
PAGES 46, 47, 48, 49, 50, 51, 52

ELEGANT BASKET Continued

STEP 3

The berries are painted next using a Q-tip. The Q-tip makes it fun and easy to form berries. You could make them luscious raspberries or blackberries. Dip the Q-tip with a slight rolling motion in the pigment. Should the end get too fat, roll it between your fingers to tighten the cotton.

As you use your colors to paint the berries making a cluster of round circles, deepen the value on the longer right section.

You can also come back with a liner to develop the shapes and make individual corrections if needed. This technique would be the same on any surface.

STEP 4

Come back with a liner and put a dot of **White** for a highlight on the berries. You can deepen the value with a little **Violet**. Be sure to clean your brush often.

STEP 5

Paint in some little green leaves next. Tuck them in amongst the flower shapes. The point of the 1/2 inch angular shader brush should be towards the outside edge of the leaf. You can become your own florist as you create these designs. Use mixtures of **Hooker Green Deep** and a little **White**. For a more watercolor appearance dilute the pigment.

Vary the shape of these leaves. Pull a little flower color into the leaves to carry the design.

STEP 6

Glide the brush to form some filler blades using the **Hooker Green Deep**. You can add a few tendrils to give it a pleasant finishing touch.

Paint the stems on the berries.

STEP 7

Now to put the icing on the painting, you can create a wonderful elegant looking basket with texture medium in the tube with the small round writing tip.

You can easily move or remove the texture medium if you need to make an adjustment.

STEP 8

Time to paint the table. Use **Violet** under the basket and glide the color in a horizontal direction. Add water to dilute the pigment to fade into the surface.

This could easily be done using either the watercolor paper or a photo album. Practice and have fun creating greeting cards and color variations. Enjoy.

Look at our new web site for Scheewe Publications at
http://www.painting-books.com

ELEGANT BASKET

ELEGANT BASKET

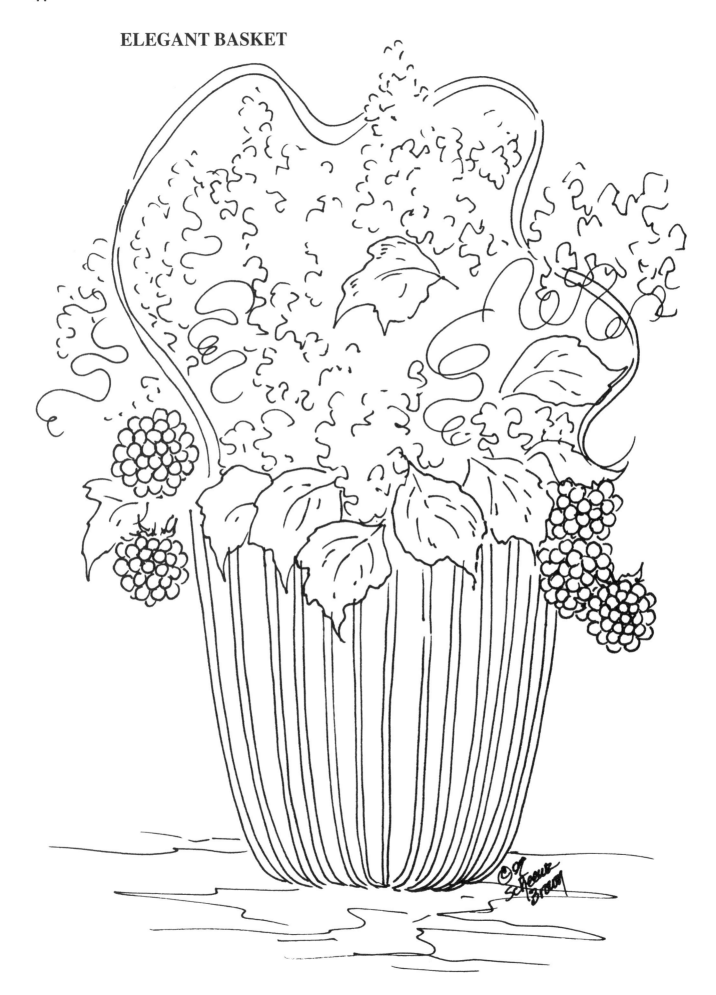

Texture Medium

There are so very many possibilities and variations that can be accomplished using texture medium.

First it is important you understand the difference between texture medium and gesso. Gesso can be applied to the surface to build texture but it often cracks in the drying process. Modeling paste is different than texture medium while designed to build texture on a surface it is both thicker and most often not as white. Texture medium was designed to be easily applied with a brush to form shapes on the surface it has been applied.

The drying time depends on water content, humidity, thickness of application, temperature and the surface to which it is applied. The drying can be speeded by heating and blowing the surface with a hair dryer.

The product can be used on watercolor paper, wood, tin, plastic or glass. Caution should be considered when putting this on a mail box as the expansion and contraction of the metal over time could crack the medium.

Place the texture medium on a disposable palette rather than your watercolor palette as it becomes extremely hard to remove once it is dry. The medium can be mixed with either watercolor or acrylic to color tint if desired. Once color has been mixed into the medium it will become permanent when dry.

You can easily apply watercolor, oil or acrylic over the dry medium. You can apply medium over watercolor or acrylic surfaces to build texture or highlight areas directly on the surface. There is some minimal shrinkage.

The texture will seal the surface of the paper so the watercolor cannot be absorbed into it. When you apply pigment over the surface the medium will not absorb pigment like watercolor paper. It becomes easy to lift off highlights on ridges since the pigment sits on the surface.

The medium is surprisingly flexible. When applied to plastic magnets for a refrigerator, the magnet finally gives out before the medium.

This medium makes wonderful texture on the surface to appear as deep snow on fir trees and snow drifts.

It is easiest to apply by picking up texture medium on the point of the angular shader and rolling the brush over once on the surface. Be sure to clean the brush thoroughly with water once you have completed the application of medium. You can also move the medium by pushing it with the plastic handle on the brush. You can put the medium in a decorator tube to form dimension if desired, great for a picture frame.

There are many texture patterns you can use with this medium. Keep in mind, if you put this on the watercolor paper and wipe it back off the paper surface it will not absorb pigment the same as paper which has not been touched with medium.

You may wish to apply only the texture medium on the paper to have an elegant appearance without pigment going over the top. It will appear embossed. You can put the medium under, over or mixed in your painting.

Have fun and experiment. I enjoy hearing about the special ways you have put the medium to use.

MORNING GLORY

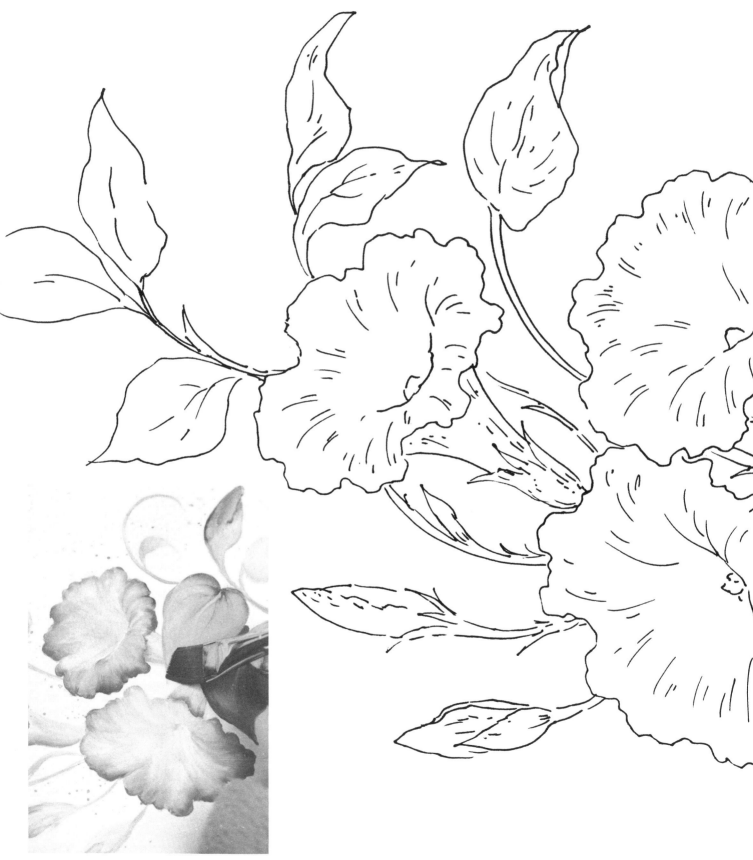

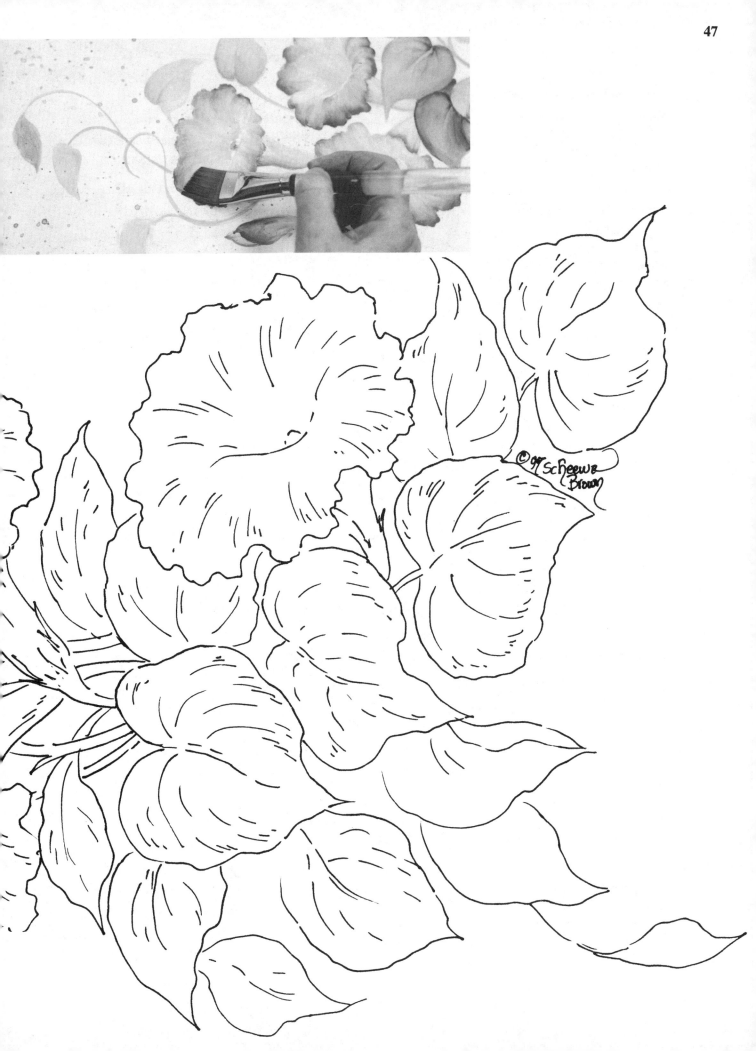

MORNING GLORY

Susan Scheewe Acrylics
by Martin/F. Weber
Opaque White S9011
Ultramarine Blue S9008
Cadmium Yellow Pale
Cadmium Yellow Medium S9003
Hookers Green Deep S9004
Hunter Green
Turquoise Deep S9007
Magenta Deep S9006
Violet S9009
Indigo S9005

Susan Scheewe Brushes
by Martin/F. Weber
Series S8012 34 Inch Angular Shader
Series S8010 1/2 Inch Angular Shader
Series S8004 No. 5 Round
Series S8017 No. 1 Liner
Series S8032 No. 0 Bristle Fan

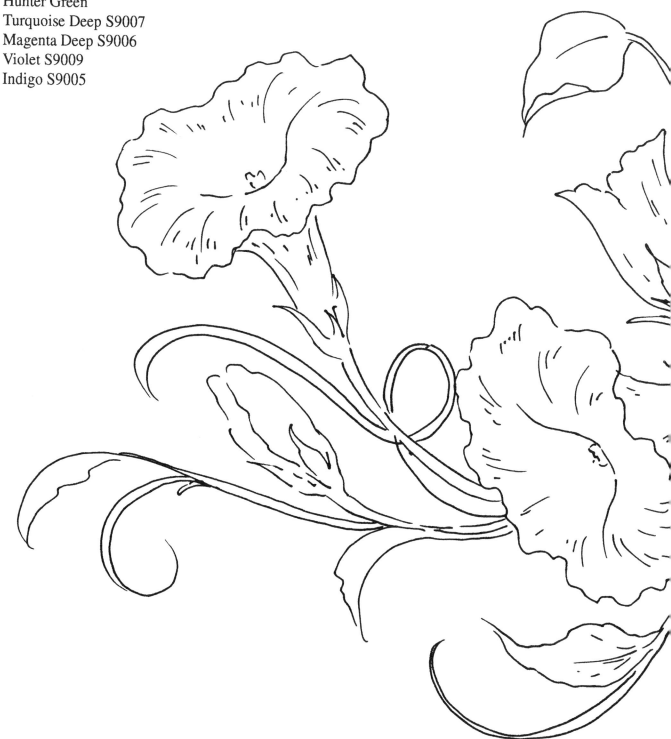

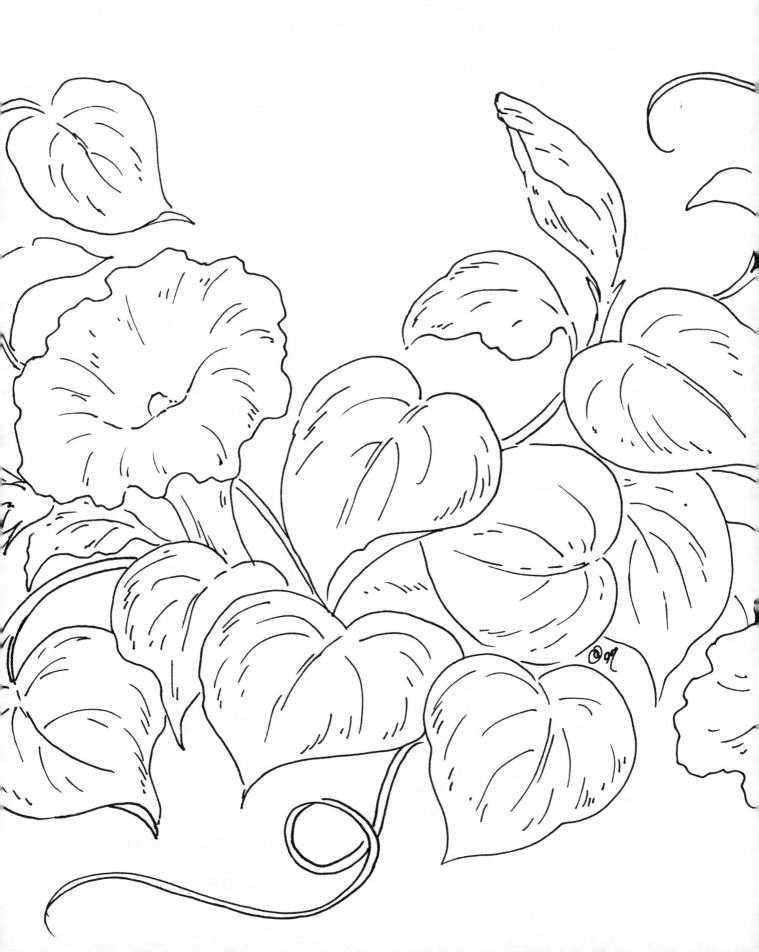

MIXED MEDIA

While not traditional, watercolors can be mixed with other water soluble media such as acrylics. Experiment on small greeting cards before you try mixing mediums on a larger painting. I use a disposable palette designed for acrylics. Don't use your acrylics in plastic palettes, the pigment can dry hard and be extremely difficult to remove if at all.

There are many wonderful variations you can use along with watercolors such as pen and ink, modeling paste, watercolor pencils and gouache. You may want to combine watercolor pencil texture with your watercolors.

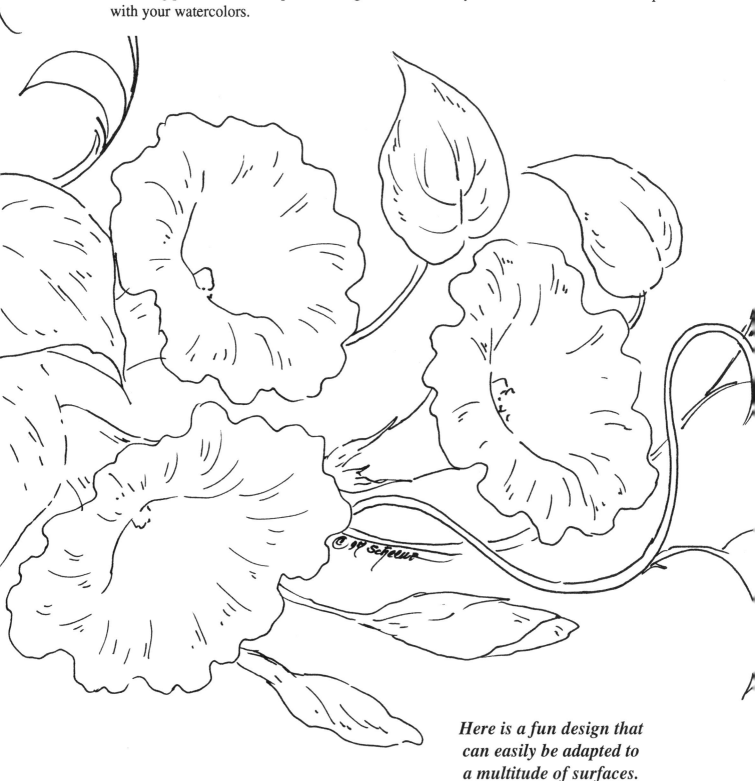

*Here is a fun design that
can easily be adapted to
a multitude of surfaces.*

MORNING GLORY

The morning glories are the perfect flower for those who want to accent a room using blues. Use this technique to decorate paintings for your home. Use either acrylic or watercolor to paint these great flowers. These are painted on top of a side table and accented by painting a watercolor to hang just above the table. This makes a wonderful balance.

It always makes the painting more understandable to read the instructions all the way through once before starting to paint.

STEP 1

Take care as you transfer your painting guide, be careul not to press too hard or you could leave a dent in the paper or wood. This painting can easily be done using either watercolors or you could dilute the acrylics and use them much like a watercolor.

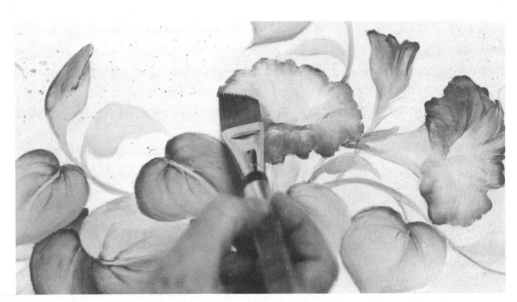

STEP 2

Using a **1 Inch Angular Background Brush,** wet the surface of the paper. By pre-wetting the entire background the pigment will diffuse easily. Start at the top of the paper applying a random pattern of diluted **Cadmium Yellow Medium.** As you paint the background you can deepen the value around the flowers or add hints of diluted greens and blues.

STEP 3

After the background has dried, start painting the top morning glory. Work one flower at a time. You may find it easier to pre-wet each flower with clean water just before painting. Dip the tip of the **Angular Shader** in **Cadmium Yellow Pale** and **Medium** and place in the center throat area and pull outward, gently lifting pressure. The shape of the flower is created by how you pull the brush into the center. Be careful not to mix the yellow into the blue as you could get a bright green.

Brush mix some **Ultramarine Blue,** hint of **Magenta Deep** and **Violet** with **White** to create the flower color. Paint a couple test flowers on scrap paper to get the desired color and feel for the shape. Place the edge of the brush in a deeper value and then to the edge of the flower rim making a slight wiggle motion to form the ruffled edge.

MORNING GLORY Continued

STEP 4

The buds are painted next and still using the **Angular Shader**. Pre-wet each bud slightly before you apply pigment. Do not paint the edges of each bud straight as the flowers seem to be in a twist that unrolls as it opens. While the buds are still wet, apply a hint of **Cadmium Yellow Pale**, touch of **Hookers Green Deep** and hint of **Ultramarine Blue** to the area next to the stem and pull upward slightly. Apply this same mixture at the base of the flower trumpets.

STEP 5

When painting these leaves start at the top of the design and work downward. The first leaves are faint and could almost disappear into the background. Applying leaves that are a soft pale color will create depth and accent the flowers. Be sure to vary the shapes. Form all the leaf shapes with a light value and slowly deepen the value. Start by slowly mixing a little **Hookers Green Deep** with the **White** and then you could make variations by adding hints of **Ultramarine Blue**, **Violet** and **Magenta Deep**. This will help strengthen the overall effect of the painting by pulling all the color together.

STEP 6

Time to give the brushes a good rinse and you might lightly spray the surface of the palette. As you go back to painting the flowers, remember to re-wet each flower with clean water. Apply the yellow mixture to the center, apply **White** with **Ultramarine Blue**, **Magenta Deep** and **Violet** tones to the outside edge. Paint the base of the trumpet with a hint of yellow next to the stem with hints of blues and **Hookers Green Deep** along the edges.

Remember, it is important to pull the outside edge into the center.

Tap on a little center in some flowers with a little **Cadmium Yellow Medium** and hint of **Country Brick**.

STEP 7

Come back and add more glazes to the leaves. Apply the deeper value on each leaf to create shading where they would fall behind other leaves or flowers. Leave the vein area with the original wash showing through and glide the **Angular Shader** along each side of the vein, lifting up on the brush as you curve the end of each leaf. The vein is lighter than the leaf. You may need to lighten the area or wipe back pigment.

STEP 8

Use a **Round Brush** with leaf variation colors to form stems and tendrils.

STEP 9

Spattering with a bristle fan is a nice finish.

OPTIONS

Think about painting this on a tall birdhouse, twisting along the edge or accent a lamp shade to tie an area together. Paint an apple basket white and spatter with blues and violets, then wrap the design around the basket to hold bath towels for guests or a flower arrangement.

INSTRUCTIONS

1. Position left on its side.
2. Apply glue to top of seat cleat
3. Apply glue to left side of edge.
4. Position seat on cleat with front of seat against cleat.
5. Secure with screws from bottom.
6. Apply glue to front of back of cleat.
7. Apply glue to left edge of back.
8. Position back at 3/4" from top.
9. Secure with screws from back.
10. Apply glue to right side edges.
11. Apply glue to right side cleats.
12. Position right side on edges as above.
13. Secure with screw from bottom.
14. Secure with screws from back.

BENCH ASSEMBLY

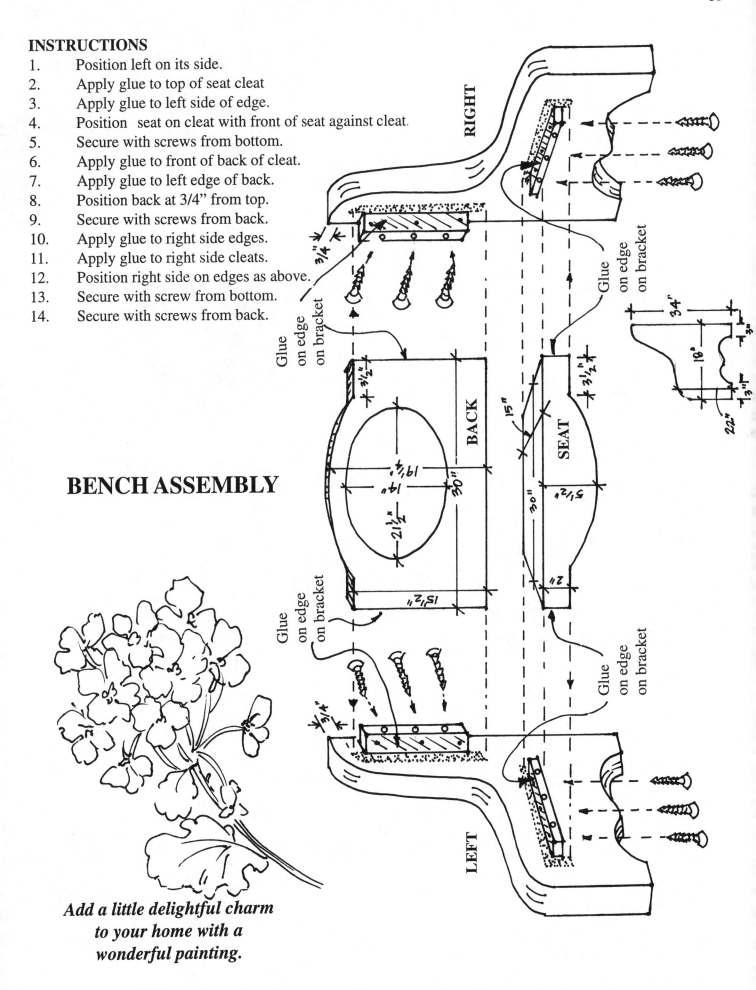

*Add a little delightful charm
to your home with a
wonderful painting.*

PANSIES

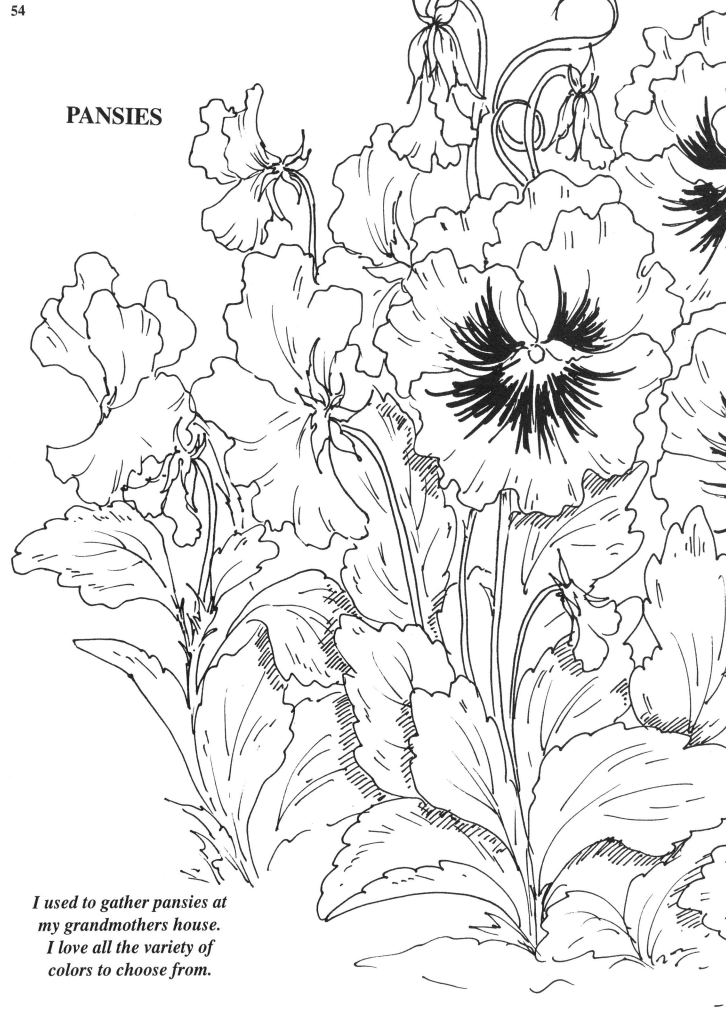

*I used to gather pansies at
my grandmothers house.
I love all the variety of
colors to choose from.*

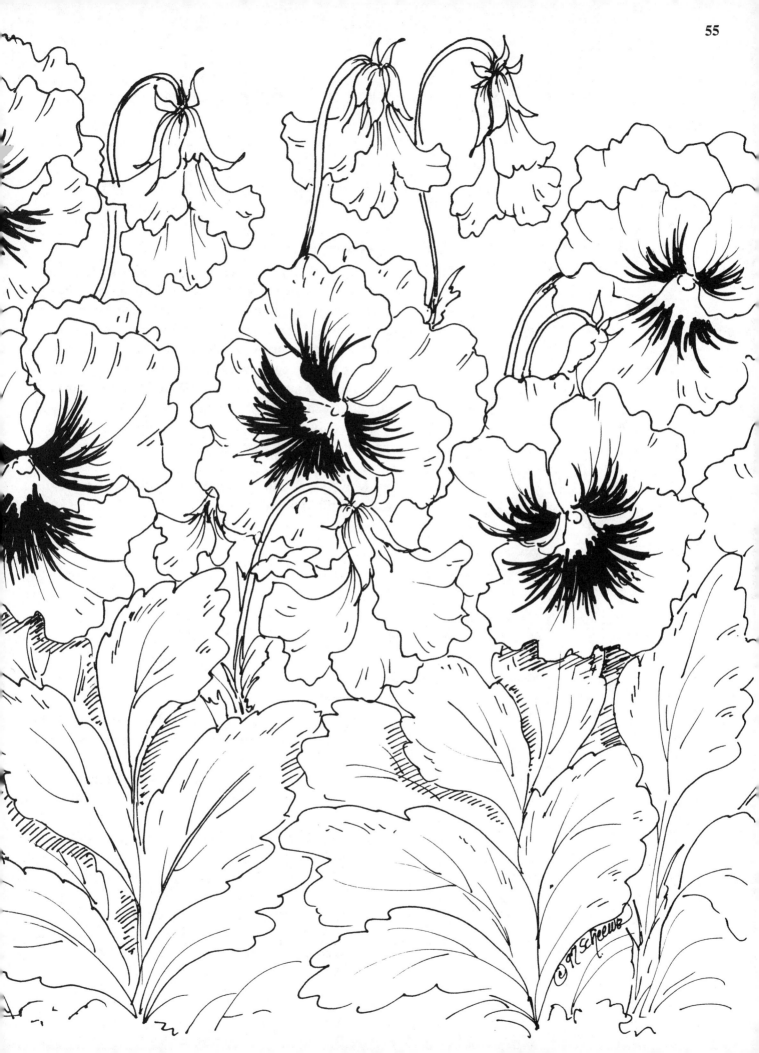

MIXING PIGMENTS

When you add water to your pigments, the value will become lighter in appearance the more water you add. It is far easier when painting to build diluted glazes rather than trying to lift out dark pigment off the paper surface.

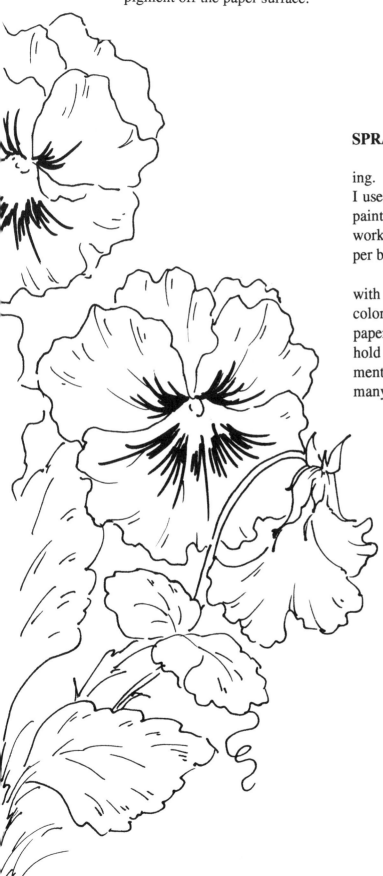

SPRAY BOTTLES

I use two different types of spray bottles while painting. I have a larger spray bottle which contains clean water. I use this larger spray bottle to dampen my palette prior to painting and as I continue to paint to keep my pigment a nice workable consistency. I can also use this to dampen my paper before I apply paint when using a wet-in-wet technique.

I use the smaller spray bottles for travel keeping one with with clean water. Play with filling a spray bottle with color, mix only about 1/4 or 1/2 of the small bottle. Keep test paper handy to check the color and distance you may wish to hold the sprayer for a certain effect. Have fun and experiment with several color mixtures. You will soon discover the many beautiful textures and applications possible.

TAPE

Tape has long been used as a painting aid while doing watercolor. Tape was available long before friskit came along.

It is important that you have fresh tape. Tape can become too sticky when it is old and could tear the surface. Tape is also sensitive to the heat and should not be sat in an area where the sun beats down on the roll.

Tape can be used to preserve the white or can be applied over a dry wash. Since papers vary in softness it's best to test the tape on an area before you apply it to the surface of a large sheet. Once the tape has been applied to the surface, don't use a hair dryer on it since this could adhere it to the paper.

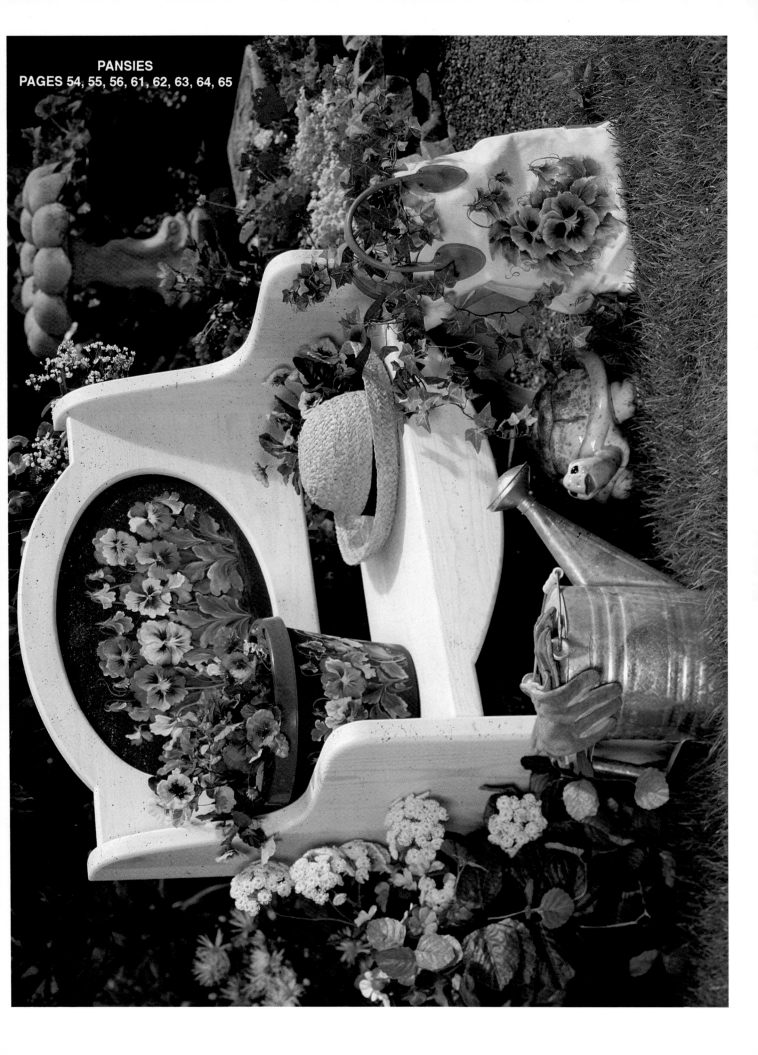

PANSIES
PAGES 54, 55, 56, 61, 62, 63, 64, 65

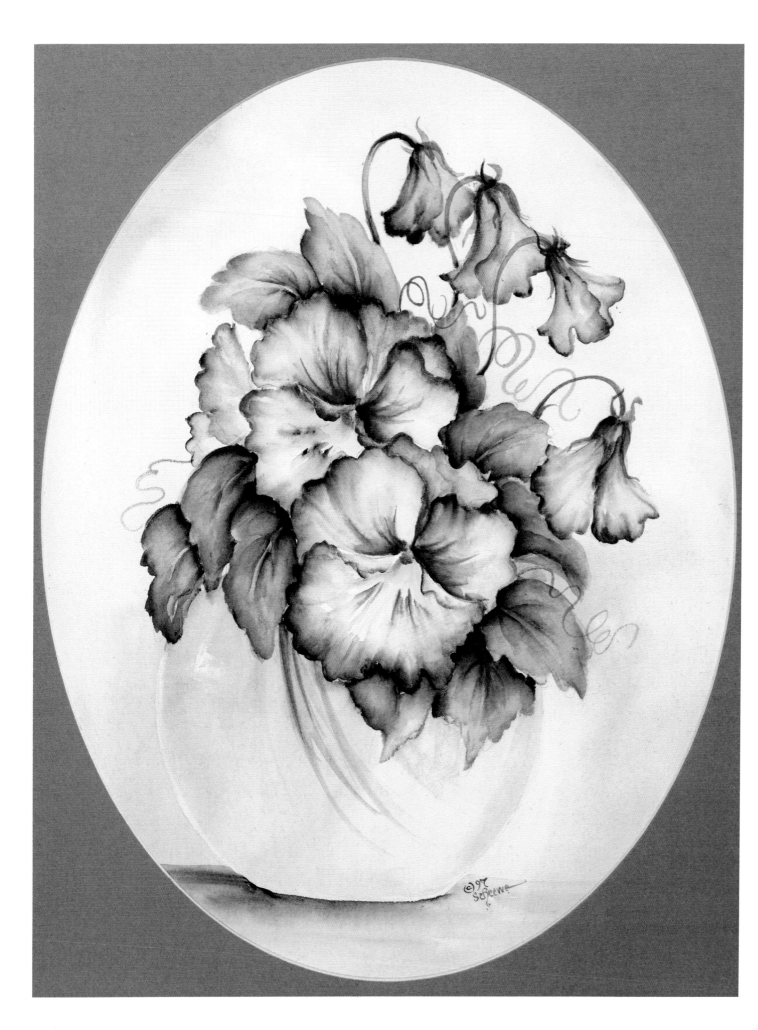

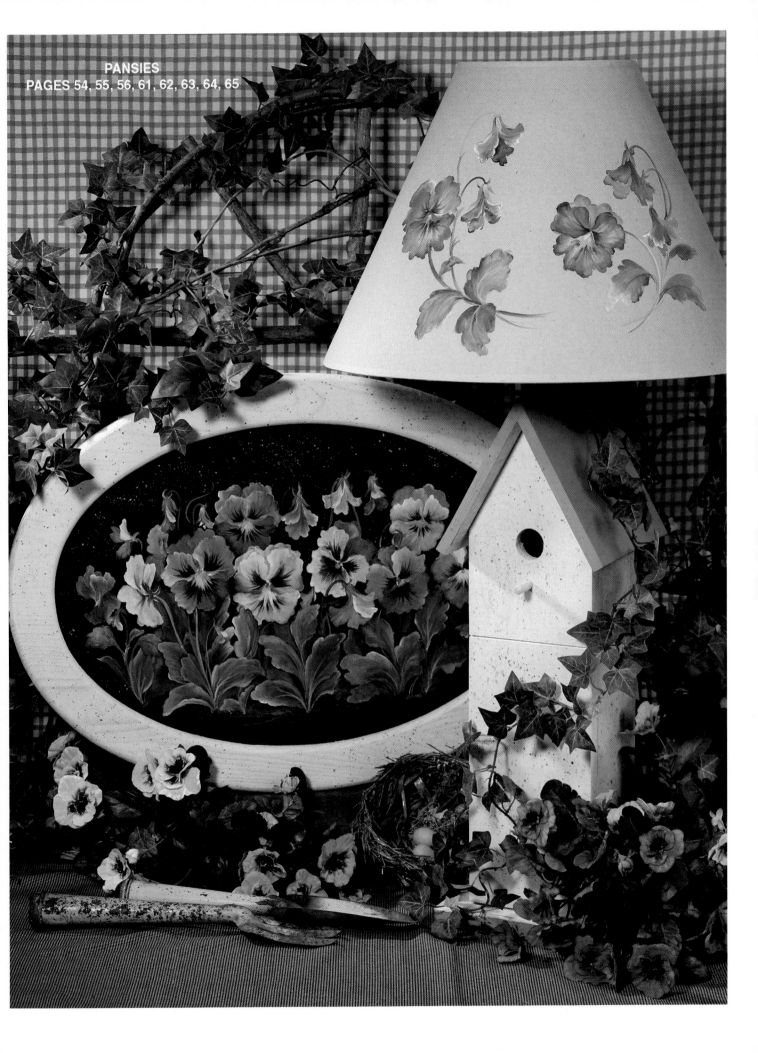

No undercoat

Undercoat

The colors are more brilliant
with an undercoat of white.

Start with the back petals,
only yellow on lower.

Work Forward

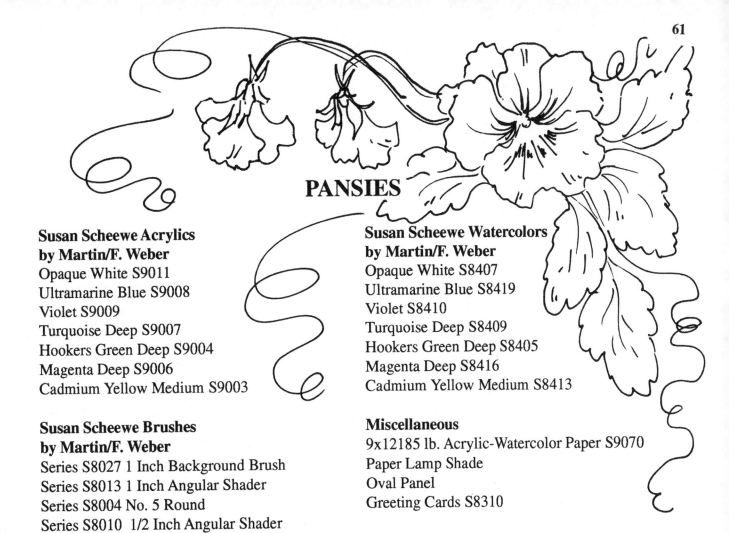

PANSIES

**Susan Scheewe Acrylics
by Martin/F. Weber**
Opaque White S9011
Ultramarine Blue S9008
Violet S9009
Turquoise Deep S9007
Hookers Green Deep S9004
Magenta Deep S9006
Cadmium Yellow Medium S9003

**Susan Scheewe Brushes
by Martin/F. Weber**
Series S8027 1 Inch Background Brush
Series S8013 1 Inch Angular Shader
Series S8004 No. 5 Round
Series S8010 1/2 Inch Angular Shader

**Susan Scheewe Watercolors
by Martin/F. Weber**
Opaque White S8407
Ultramarine Blue S8419
Violet S8410
Turquoise Deep S8409
Hookers Green Deep S8405
Magenta Deep S8416
Cadmium Yellow Medium S8413

Miscellaneous
9x12185 lb. Acrylic-Watercolor Paper S9070
Paper Lamp Shade
Oval Panel
Greeting Cards S8310

Pansies grow almost everywhere and these old fashion favorites can bring color to enjoy in your home all year long in delightful paintings. All the bright and beautiful colors can be used to paint the happy faces of these flowers. They look so real you can almost smell their sweet scent. Using either acrylic or watercolor, use this technique to paint surfaces you will find at home.

VARIATIONS OF SURFACES

While you can paint these on so many different surfaces when using acrylics it will be important to apply a **White** acrylic undercoat when painting on a dark surface when bright flowers are desired. Use these techniques as a springboard for ideas for you to use in your own painting.

A great advantage when using acrylic is not only the quick drying but, you can also go over an area should you change your mind or need to lighten an area.

You can order a set of videos that show step by step each of these instructions. It is just so very helpful to watch how the brush is used. I always try to give as many helpful suggestions as possible as it is so much fun to paint, I want your painting to be fun.

**Source For Oval Panels, Frame, Bench
 Stan Brown Arts and Crafts**
 13435 N. E. Whitaker Way
 Portland, Oregon 97230
 (503) 257-0559 Telephone
 (503) 252-9508 Fax
 e-mail: SBrown 4207 @ aol.com

Thank You

Follow the technique used in Pansies. You could paint this arrangement on watercolor paper, or try it on a tote bag using acrylic. Painting clay pots is a great warm up and makes a wonderful gift to have on hand.

Whether you chose watercolor or acrylic, you can turn paper, canvas, a charming wooden bench, a lamp shade or any number of objects into works of art. When dry, your acrylics automatically will be permanent. If you want to put watercolors on objects such as baskets, however, you will need to go over them with a coat of varnish to make them last. When using watercolors on paper you should always use glass to protect the surface.

STEP 1

Assemble your materials. Get out your watercolor palette and/or put your acrylics on your acrylic palette. You will need a container and a spray bottle filled with clean water. Also, keep a roll of paper towels handy. Remember to rinse your brushes often. If your acrylics start to film over, mist them lightly with clean water to keep them damp.

STEP 2

You will need to start with a light pencil sketch or you can transfer the painting guide. It's important to place your flowers so they aren't all facing forward. Some blossoms in side view, plus a few buds here and there, will seem more lifelike. You can do a painting on paper or canvas, but this design works well on so many items that you can try many surfaces.

STEP 3

Paint a greeting card on the acrylic- watercolor paper or do a small 9 x 12 painting on the acrylic-watercolor paper. Using acrylics with a watercolor technique, begin with your **1 Inch Angular Shader** and apply clean water until the surface has an even shine. Then, with long, gliding strokes use some diluted **Violet** and diluted **Turquoise Deep** to create a nice, soft background. The damp surface lets the acrylic pigment diffuse in much the same manner that watercolors do. Let the colors mingle on the background.

STEP 4

While your paper is drying, you can start to paint another object, such as a paper lamp shade. In this case, there is no need to pre-wet the surface.

You could apply a rich deep forest green base paint on an oval panel cut to fit the bench or frame. These interchanging panels create a delightful decorator item for home decor.

You may want to paint the design on a deck chair, flower pots or watercans. This is a great time to gather many objects to apply this technique. Decorate an entire patio or room carrying the theme. Paint a friend a keepsake.

STEP 5

Pansies come in beautiful variations of colors, often on the same plant each flower will appear different. Each flower has five petals. These could be painted on all surface using acrylics.

You can often see a happy face on the flowers. The lower large petal has what appears as the mouth with the eyes on the two petals directly above. To form the flowers, first paint the petals in back. Place the point of your brush toward the outer edge of the petal, press lightly so the full chisel edge of your brush is in contact with the surface. Pull the brush around the petal edge with a slight wiggle motion, this will form a ruffled appearance. It is helpful to paint the **Cadmium Yellow Medium**, **Cadmium Yellow Pale** mixed with a hint of **Opaque White** on the varieties that have yellow toward the center of the flower and blues or violets near the edge. Paint this on the lower petal. Next paint the middle petals, then the bottom petal.

Most often you will find the **1/2 Inch Angular Brush** easy to control and a good size for painting these flowers. Apply more pigment to the point of the brush using your favorite mixtures of colors. Have lots of clean water and paper towels handy to clean your brush often and make fresh mixtures of color.

PANSIES Continued

STEP 6

Use either the chisel edge of the **1/2 Inch Angular Shader** or a **No. 5 Round** to paint the eye and the mouth area that often come from the center of the flower and form the appearance of the eyes and mouth. These lines will vary on each flower in placement and length. It really is helpful to have a cluster of fresh flowers as a reference as you paint. The lines will follow the contour of the petal so be careful to paint those gentle curved contour lines. Often **Violet** is an excellent color to use in these areas.

STEP 7

Use the **No. 5 Round** to paint the little round seed in the center of the flower using **Hookers Green Deep** and a hint of **Cadmium Yellow Medium**. Rinse the brush and apply a hint of **White** on each side of the seed.

STEP 8

Paint many buds on your surface. The buds are important to the appearance of a painting. A common mistake when creating a design is to have all the flowers full size facing forward and forgetting how petals twist and turn in a bouquet. Again, refer to your bouquet or photos as a reference. Be careful not to paint the leaf or green area of the bud first.

Use the **1/2 Inch Angular Shader** to apply color mixtures using acrylics. You could first apply **White** on the brush and then on the point of the brush pick up a little **Violet**, **Magenta Deep** or color of your choice, give the brush a twist and then glide it towards the stem area. Clean your brush. Do not use white if you are painting with watercolors.

STEP 9

Using either a **No. 5 Round** or tip of **1/2 Inch Shader** to paint the stem and the top of the bud. You may rest your little finger on the surface to give balance as you glide on the stems and small leaf section. Lift up the point to form a graceful taper on the cap area. Use variations of mixtures of **Cadmium Yellow Medium, Cadmium Yellow Pale, Hookers Green Deep** and **Turquoise Deep**. Note: the cap has a little section that comes forward.

STEP 10

Time to paint the leaves, use a **1/2 Inch Angular Shader**. When you brush mix variations of **Cadmium Yellow Medium, Cadmium Yellow Pale, Hookers Green Deep**, hints of **Violet** and **Ultramarine Blue** you will create leaves with life. Do not mix up a green color and apply it to all the leaves as it would appear flat and dead in appearance. Remember that leaves come in a variety of sizes and twist and curve gently. Adding more glazes will give depth to your painting. Place the point of the brush towards the outer edge of the leaf. Lightly press the entire brush on the surface and make a slight circular movement to form the edge. Using a variety leaves will make a more realistic appearance along with a few curls, imperfect areas and rust spots. Mother Nature really creates so many wonderful variations, take a moment to study the leaves on a plant or photo.

STEP 11

I enjoy spattering a surface to break up the background but, this is only an option. Using diluted paint with the flower color you have selected, pull back on the brush with your finger and spatter color on the surface. Have a paper towel handy to quickly blot unwanted spatters.

BRUSHES

Excellent quality brushes are extremely important to your painting results. The brushes I use are the Sue Scheewe signature brushes, manufactured by Martin/F Weber Co..These wonderful brushes are designed to execute the many different watercolor techniques with ease. Thirty years of teaching and painting was brought into the design and selection of these superior brushes.

Please note that each series number is a different configuration of brush (the handle as well as the hairs). In each series there is several sizes of brushes available. The size of the brush you use, depends on the size of the painting.

The brushes can be used for watercolors and acrylics as well as for oil. *However* , once they have been used with oils, mark on the handle with a permanent marker the word oil. These brushes should then be kept for use only with oils. I have a set of these brushes for oil use. It is extremely helpful to have a couple of your favorite brushes in the same size and series so you will always have a clean brush ready to apply fresh color. While these brushes have great strength and durability, they will wear with harsh use and need occasional replacement as any brush would.

ANGULAR SHADER

This is one of my very favorite brush series. The shape allows so many possibilities and ease of painting. When loading only the point of the brush with pigment it is easy to achieve a beautiful gradation in color. The brush can be turned or twisted to fit into small spots as well as with larger areas. We should never use just one brush but if I had to this would be the brush.

ROUND

The round brushes should have a taper that comes to a sharp point. These are excellent for painting details. These create beautiful flower petals on daisies, graceful tree trunks and branches. They can also be used to wash in large areas. The rounds are capable of a stroke which varies from thin to thick appearance. This is a very traditional brush.

LINER

The liner is excellent for creating continuous lines without running out of paint. The pigment flow smoothly down the fibers making it easy to paint small details.

FILBERT

With a twist of the wrist this brush makes beautiful flower petals and ribbon shapes. The chiseled edge is wonderful for drawing lines.

FLAT

These excellent flat brushes taper to a sharp point. The flats are fantastic for laying in a wash.

BACKGROUND ANGULAR

This is a wonderful brush to lay in backgrounds. The angular configuration makes it extremely easy to cut in around flower shapes.

FAN BRISTLE

The bristle fan makes it easy to pull up and create grass and foliage. Tapping the brush up and down lightly can create the appearance of tree foliage.

Brushes are one of your most important tools.
They make a huge difference in the results you can achieve.

Blue Masking Fluid

This is a liquid friskit which is excellent to preserve white areas in the paper. The use of Blue Masking Fluid is extremely helpful and makes completing paintings that you want to save from pigment during the painting steps easy to complete. It is most often used to protect the surface while painting the background, but it can also be applied over dry pigment to save light values. If you plan a painting that require small areas, intricate designs or shapes to be saved, this is an answer to your problems. It is important you read all these directions before you start to use the friskit.

CAUTION - Prior to placing the brush into the masking fluid, dampen the brush, then rub your brush against a bar of soap; this will protect the hairs of your brush from being damaged by the Blue Masking Fluid. Repeat this step frequently, leaving soap on the brush while using the Blue Masking Fluid. Once you are done applying Blue Masking Fluid, immediately wash the brush in warm tap water to completely remove the masking fluid. Blue Masking Fluid has a soft light blue color, it will not stain the paper, it is only tinted so you can easily see where it has been applied. Allow the Blue Masking Fluid to dry completely before going on to the next step, it will feel rubbery. **DON'T** try to speed the drying with a hair dryer as the heat could bond the Blue Masking Fluid to the paper surface. The light blue color settles to the bottom of the jar, stir the jar to pick up color, **DON'T** shake it as it causes the fluid to have air bubbles.

CAUTION - Some papers could be too soft and when you remove the Blue Masking Fluid it could shred or tear the paper. Since different papers vary, it's a good idea to always test the Blue Masking Fluid on a scrap of the same paper you intend to use. Problems could arise if you remove the Blue Masking Fluid while the area around it is not completely dry, as the paper is fragile and could tear. The paper surface should be **COMPLETELY** dry before removal.

The masking fluid should be removed very gently. Use either a rubber cement eraser or a small piece of masking tape to lift off this material slowly, do not rip quickly. Don't press the masking tape hard on the surface as it would damage surrounding paper.

Using the Blue Masking Fluid really is easy

APPLE TIME

Susan Scheewe Acrylics
by Martin/F. Weber
Cadmium Yellow Medium S9003
Cadmium Yellow Pale S9015
Cadmium Red Light S9002
Magenta Deep S9006
Hookers Green Deep S9004
Burnt Umber S9001
Burnt Sienna S9000
Turquoise Deep S9007
Opaque White S9011
Violet S9009
Indigo S9005

Susan Scheewe Brushes
by Martin/F. Weber
Series S8012 3/4 Inch Angular Shader
Series S8010 1/2 Inch Angular Shader
Series S8004 Size 5 Round

Wood Source
You can order the oval frame or bench from:
Stan Brown Arts and Crafts
13435 N. E. Whitaker Way
Portland, Or. 97230
(503) 257-0559 Telephone
(503) 252-9508 Fax

PREPARATION

Birdhouse: Base - White Lightening
Bench Oval: Base - White Lightening
Bushel Basket - Varnish

These luscious apples are a wonderful subject to paint. The bright colors almost pop off the surface. You can easily see how they brighten a charming birdhouse or add a perfect spot of color to a room. This design can decorate many items and your surface could be almost anything, including fabric and wood. You can also create a painting on acrylic-watercolor paper to put into a frame. If you paint on fabric or canvas, you can apply pigment directly to the surface. If you paint on wood, you will want to put on a coat of sealer or apply a base color prior to starting your apples. There are so many beautiful decorator colors it is difficult to pick a favorite. I used a white wash background which is very neutral but, you could use rich golden colors which are also very popular. Should you select a dark background I would suggest you apply an undercoat to the apples and forward leaves with Opaque White. Brush direction could show as you apply an undercoat of white so take care as you apply pigment. Allow this undercoat to dry completely prior to applying pigment so the colors applied on this area will appear bright.

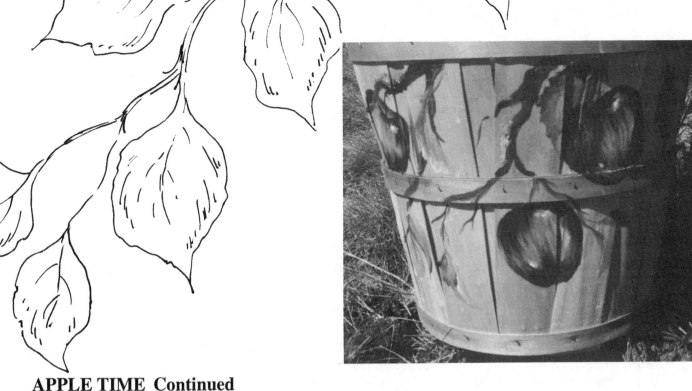

APPLE TIME Continued

It is always helpful to have a few fresh apples to look at for a model as you paint. There are so many delicious varieties of apples it is easy to find those you find most eye appealing. I always like a great variety for reference and the bonus of eating a few as you paint.

I painted these on the P.B.S. series using the oval insert that can be placed in a bench or easily framed. You could select acrylic-watercolor paper or wood. It is my hope the options will give you the creative freedom of choice.

It is always easier to paint at an angle on an upright easel or your portable easel. It is really difficult to paint on a flat surface. Sit in a comfortable position to paint.

STEP 1

Once you have created your design on the surface you will want to start by painting the apples. If you are painting red apples it is important to paint the light area first. Often you will see light yellow areas in red apples, if you are painting with watercolors, reserve a large area and if you are using acrylics apply a mixture of **Cadmium Yellow Pale** and a little **Opaque White** to the center area of each apple using a **1/2 Inch Angular Shader**. The contour is very important so continue to think of shape as you apply pigment. Often there is a light area at the top of the apple core area.

Using the **1/2 Inch Angular Shader** apply **Cadmium Red Light** along the outside edge. Lightly pull some of this color into the light area as the streaks will form a more realistic appearance. As you form the apple shape be careful not to form a forward section at the top core area that separates the front and back of the apple.

Using the **1/2 Inch Angular Shader**, mix **Cadmium Red Light** and **Magenta Deep** and deepen the value towards the outside edge. You can make an even deeper value by adding just a little **Violet**.

With a clean brush, add highlights using **Opaque White**. Use either the tip of the **Angular Shader** or a **Liner** and apply little dots of **Opaque White**. Look at a real apple and you will see these spots of white.

When using the acrylics, you can add a mixture of **White** and hint of **Turquoise Deep** making a light blue and apply to the outside edge of the apple as a reflected light.

APPLE TIME Continued

STEP 2

Paint the branches using the **1/2 Inch Angular Shader** with a mixture of **Burnt Umber** and **Burnt Sienna**. As you pull the brush to form the branches, wiggle the bristles to form a more realistic appearance of an apple branch rather than a straight stiff appearance. It is so helpful to look at tree branches before you paint them. Often you can see lichen on the older tree branches, tap on a little **White, Cadmium Yellow Light** and hint of **Hookers Green Deep**. Variations of shape, color and size all add to the depth created in your painting.

STEP 3

The leaves are painted with layers of glazes. Start with your **3/4 Inch Angular Shader** brush, mixing soft pastel greens and then add deeper values. Use mixtures of **Opaque White**, a hint of **Cadmium Yellow Medium** and some **Hookers Green Deep**. As you deepen the value add hints of **Turquoise Deep, Indigo** and hints of **Magenta Deep**.

It is easier to form the leaves by placing the point of the brush toward the edge of the leaf shape and working from the stem to the tip on each side. As you deepen the values, look to see what leaf area would be in shadow, cast from the apples or leaves that are more forward. Press the chisel edge of the brush slightly up and down to form a slightly ragged edge on your leaf. The back side of the leaf is lighter than the front, you will want to add **White** to your acrylic mixtures to give this appearance or dilute the watercolor with water to lighten. To form the impression of a leaf curl, first lighten this section and then add **White** to the very edge to form the curl.

You will want to come back with additional glazes to give a richness to the painting. Adding the appearance of an irregular edge that appears as a blemish or area eaten by a creature, again adds that nice realistic appearance. Apply a touch of **Burnt Umber** or **Burnt Sienna** on the tip of the brush and form these areas.

STEP 4

To connect the apple to the branch, stroke on a graceful thin stem using your **No. 5 Round** brush with a mixture of **Burnt Sienna, Magenta Deep** and a little **Burnt Umber**. A few touches of **Hookers Green** are great. Be sure to wash your brushes often when you use acrylics. This might also be a great time to stop for a minute and get fresh water in your containers.

STEP 5

Check to see how much your highlight appears. You may want to add a little stronger highlight or make a few color adjustments.

STEP 6

Now come back and refine the leaf shapes. This is the time to apply adjustments to add more depth to your painting. Form the appearance of a vein in the leaves by applying color to each side of the vein leaving the lighter glazes to remain in the vein section or you can apply a mixture of **White** with a little **Hookers Green** to the center section. Be careful not to paint the vein from the stem to the tip of the leaf or it will almost appear as two separate leaves.

You may want to come back with a few diluted glazes of **Cadmium Yellow Pale** and **Cadmium Yellow Medium** to form a little sunshine. It is also nice to introduce a few glazes of **Magenta Deep**.

APPLE TIME Continued

FINISHING

Give yourself and the painting a rest and come back another day and add any adjustments you may desire.

Should you desire a step by step variation using watercolors you can order "The Garden Scene" No. 339 by Susan Scheewe Brown. You can also order the complete set of videos "Le Jardin" showing most of the techniques used in this book.

It is always a pleasure to hear from you and how you created your own paintings. If you send me a photo I will be happy to return it.

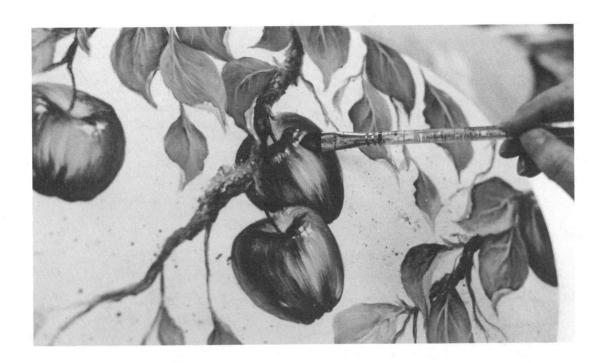

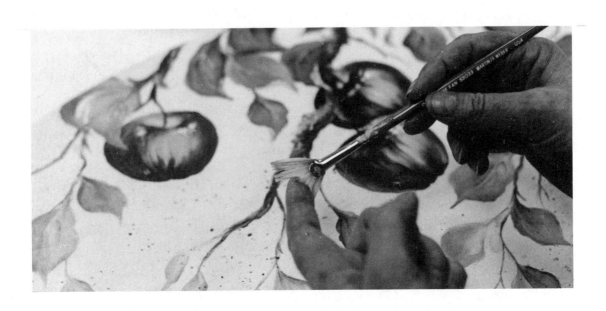

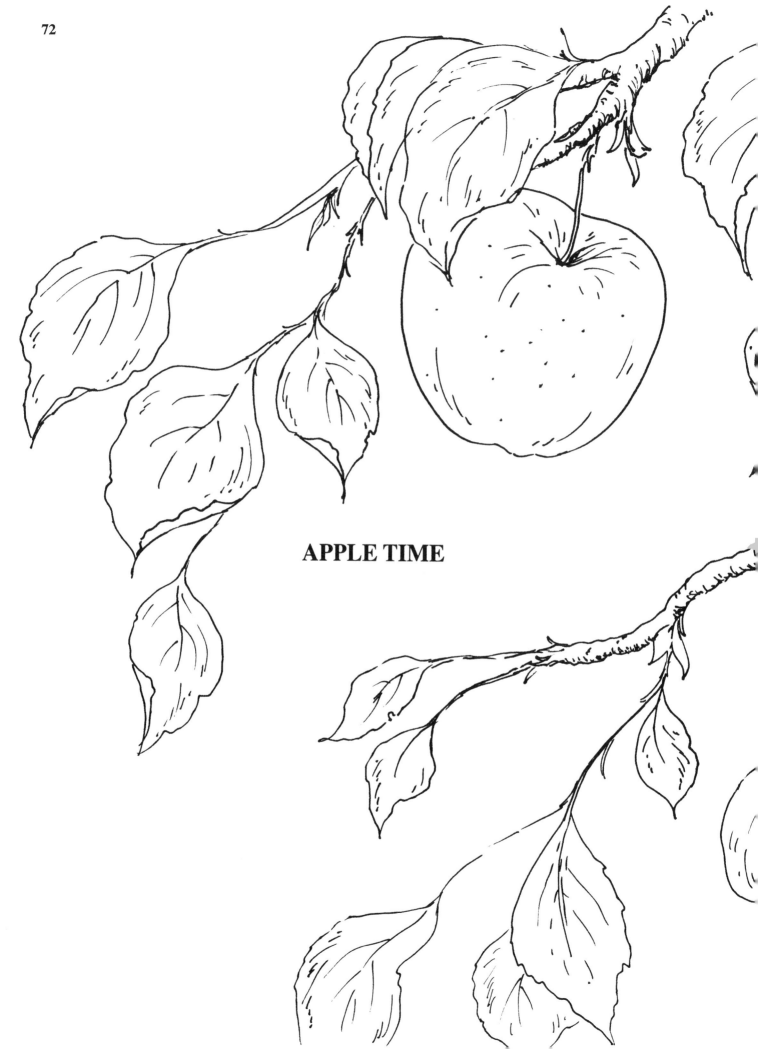

APPLE TIME

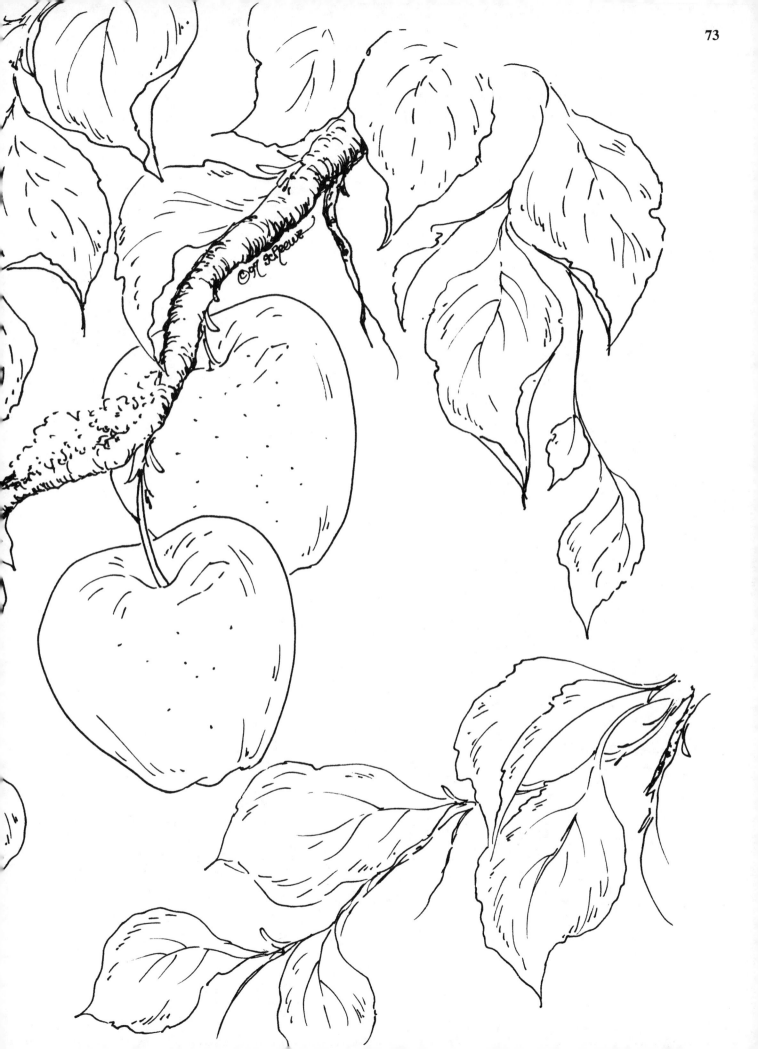

*Fall's bountiful harvest
is celebrated in this seasonal painting.
Paint this for a special friend.*

FALL HARVEST

Susan Scheewe Acrylics
by Martin/F. Weber
Opaque White S9011
Cadmium Yellow Pale
Cadmium Yellow Medium S9003
Cadmium Red Light S9002
Magenta Deep S9006
Burnt Umber S9001
Violet S9009
Ultramarine Blue S9008
Hookers Green Deep S9004
Country Brick S9010

Susan Scheewe Brushes
Martin/F. Weber
Series S8012 3/4 Inch Angular Shader
Series S8010 1/2 Inch Angular Shader
Series S8004 No. 5 Round
Series S8017 No. 1 Liner
Series S8032 No. 0 Bristle Fan

OPTIONS

You may want to paint a few wheat stocks or add some chinese lanterns that bloom during the fall harvest season. Paint this on a picnic basket and fill with homemade goodies or fruit to take as a birthday gift or thank you for the host or hostess for a holiday stay.

FALL HARVEST

As you paint this Fall arrangement you can see how easy it is to create a bright color on a dark background. You can paint this on a mat for a table centerpiece, the bench or a painting for the wall. The interchangeable panel that fits in the bench also has a frame you can purchase instead, if you have limited space. The delightful change of seasons brings a festive time of year with celebration of the Fall harvest and family gatherings. Autumn colors are flowing, fiery and rich. Paintings become a joy for years to come and a memory of special times. Use this as a centerpiece for a Halloween or Thanksgiving party. You may want to protect the surface with plastic if you use it for food. Have your friends or family members who attend a special occasion write on the backside of the painting, being sure to include the year and date held. Be sure to include the younger children as you sign the back, as the years go past it will soon become a wonderful treasure of time.

This could easily be completed on a variety of sizes. Use this pattern for thank you notes, invitations and thinking of you note cards.

STEP 1

You will want to transfer the painting guide to a dark surface using white graphite, chalk pencil or rub white chalk on the back of a design.

STEP 2

Using acrylic, apply a layer of **Opaque White** with a **3/4 Inch Angular Shader** to the pumpkin shape. Brush direction is important as you form the contour. This underpainting should dry completely before applying pigment. The white undercoat will allow bright colors to appear on the dark surface.

STEP 3

Apply color to the dry undercoat. Use a **3/4 Inch Brush** and apply **Cadmium Yellow Medium** and **Cadmium Yellow Light** to the right section. As you work toward the edge on the right and the left side, mix **Cadmium Yellow Medium** with **Cadmium Red Light** to make a rich orange. Brush direction is important as it will form the contour. Deepen the values towards the right and far side by brush mixing **Cadmium Red Light** and **Magenta Deep**. Add a few hints of **Hookers Green Deep**. Allow the pumpkin to dry before you apply sections.

STEP 4

You want to begin by putting a foundation on the leaves. The first step is thinking about the light and dark values. As you apply more layers of color, the additional layers will appear brighter. Pick up more pigment on the point of the brush. Place the point of the brush towards the outside edge of the leaf. For a more festive appearance, you may want to add hints of acrylic **Gold**.

STEP 5

Under the pumpkin, create a base. With the **3/4 Inch Angular** brush apply **Burnt Umber**. You can create a more textured appearance by lightly dabbing some **Cadmium Yellow Medium** and a hint of **Opaque White** with a sponge over this dark application of color.

STEP 6

Fall flowers are always a delightful accent. You can paint the flowers in fall colors of your choice or use **Cadmium Yellow Medium**. Use a **No. 5 Round**, pick up pigment. Place the point of the brush at the tip end of each petal, pulling toward the center lifting up pressure to create a tapered stroke. Do only the top flower.

You can pick up touches of **Cadmium Red Light** as well to accent the petals.

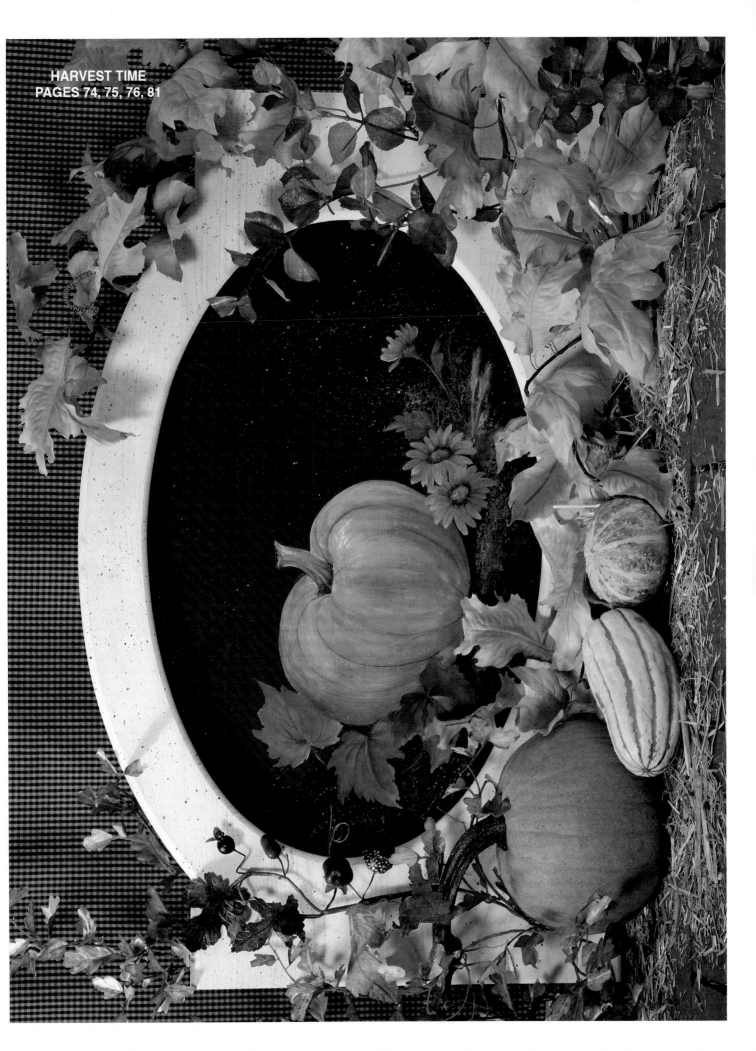

HARVEST TIME
PAGES 74, 75, 76, 81

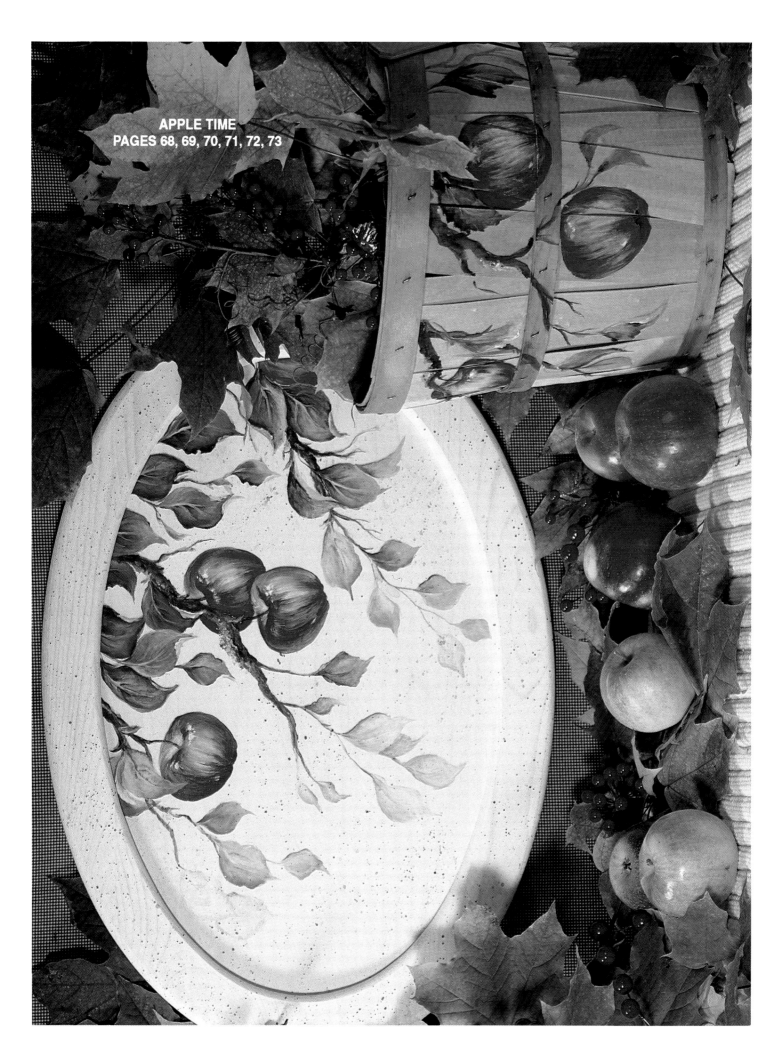

APPLE TIME
PAGES 68, 69, 70, 71, 72, 73

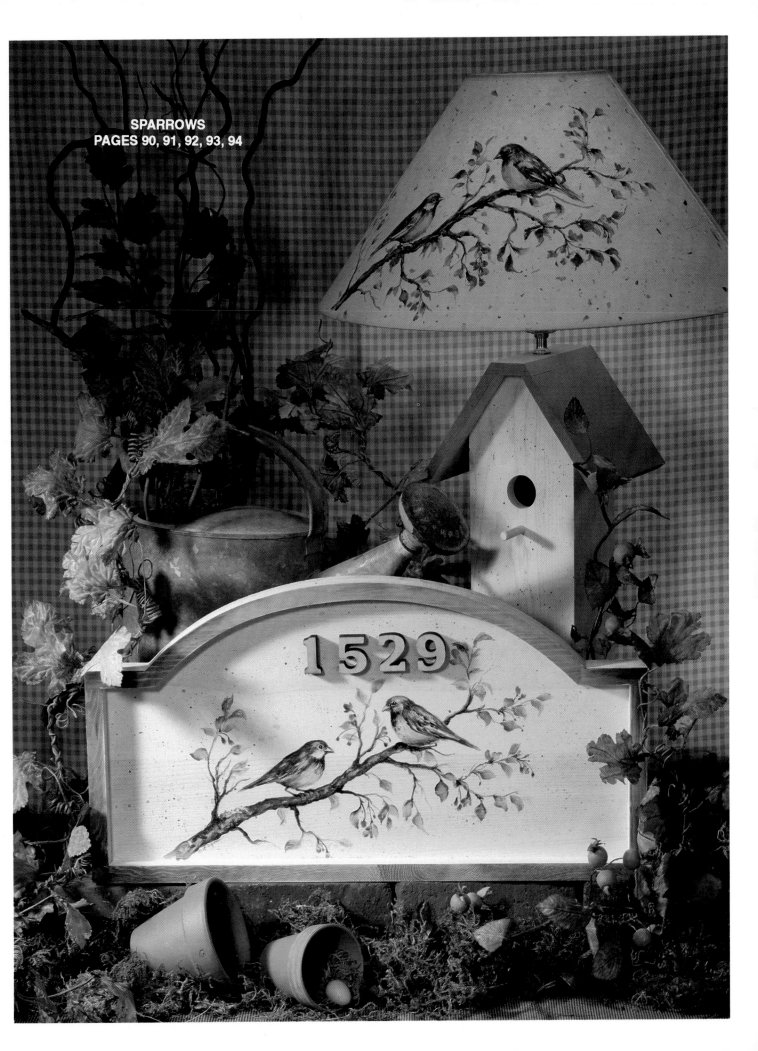

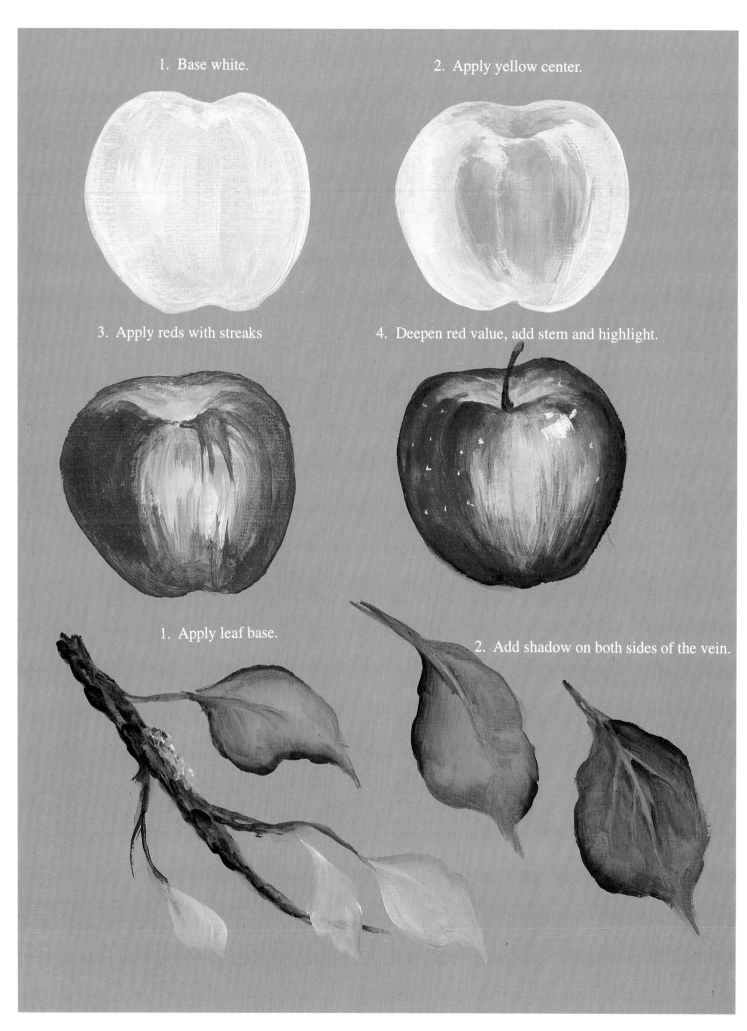

1. Base white.

2. Apply yellow center.

3. Apply reds with streaks

4. Deepen red value, add stem and highlight.

1. Apply leaf base.

2. Add shadow on both sides of the vein.

FALL HARVEST Continued
STEP 7

Use a **No. 0 Bristle Fan** and pick up water to make a soupy puddle in your **Cadmium Yellow Medium, Cadmium Red Light** and even a little **Opaque White**. Place your finger under the bristles and spatter on the background. Variations of color will add interest to the background. Should you get too strong a spatter, quickly blot the surface with a clean dry paper towel.

STEP 8

Use a **1/2 Inch Angular Shader** to paint the leaves to go with the flowers. Brush mix variations of Autumn colors along with touches of **White**. Apply pigment also to the stem and back of the flowers. Clean your brush.

STEP 9

Continue to paint the flowers. Use a mix of **Cadmium Yellow Pale** and **Medium** plus touches of orange mixtures on your palette. Start with petals to the back and work forward. The contour of each petal is important. Dab **White** and **Cadmium Yellow Pale** in the center area. You may want to add another layer of petals for a more full flower or to brighten a petal.

STEP 10

Lightly tap more color in the center of the flower. Start with a **Cadmium Yellow Medium**, tap on a little **Cadmium Yellow Pale** and then add a **White** highlight.

STEP 11

Now is a great time to add more glazes on the pumpkin. Refer to the photo as a guide. Using a **3/4 Inch Angular Shader** apply a repeat of the first colors. A slightly irregular design will appear more realistic.

STEP 12

Paint the stem using a mixture of **Hookers Green Deep** with a little **White**. Add a few touches of **Country Brick** at the base and pull up lightly.

STEP 13

As a rule, the leaves that fall behind are deeper in value, but the delightful bright shades on the Fall leaves can vary. Apply a second layer to refine the color and shape.

You can add so much richness and depth as you continue to build values. Don't put paint on the vein area, but paint on both sides of the vein. Place a hint of pigment on the point of the angular shader and paint on both sides of the base color.

STEP 14

Use just a hint of **Burnt Umber** to paint some appearance of separation on the pumpkin sections. You may want to add a hint of **Country Brick**. Don't over work them and create a stiff unrealistic appearance.

As a final touch, you can mix **White** with **Ultramarine Blue** and make a soft blue value. Lightly glide a little of this mixture on the left edge and a hint on a couple of leaf sections as a reflected light. Look at the photo as a reference.

STEP 15

Tap on a few dried filler flowers to tuck in around the leaves using the rich Autumn shades.

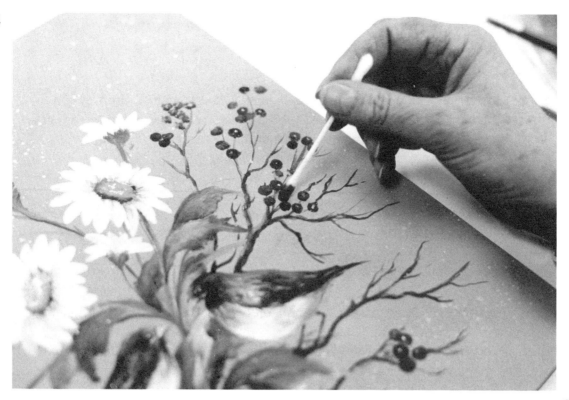

THRUSH

Susan Scheewe Acrylics
by Martin/F. Weber
Opaque White S9011
Burnt Umber S9001
Cadmium Red Light S9002
Indigo S9005
Mars Black S9012
Cadmium Yellow Medium S9003
Hookers Green Deep S9004
Turquoise Deep S9007
Ultramarine Blue S9008
Cadmium Yellow Pale S9015
Magenta Deep S9006
Violet S9009

Susan Scheewe Brushes
by Martin/F. Weber
Series S8004 No. 5 Round
Series S8017 No. 1 Liner
Series S8010 1/2 Inch Angular Shader

SURFACE CHOICE
140 lb. Cold Press
Lamp Shade
Wooden Memory Album from
Walnut Hollow
Q-tip

The thrushes visit our bird feeder. Their beautiful coloring will bring warmth to brighten a special spot in your home. A special way to welcome friends or make a memorable keepsake on an album for newlyweds. Decorate a lamp to bring a cheerful spot to a room.

What would be a more delightful surprise than a painting for a loved one. Paint an album for a wedding anniversary and fill it full of photos for cherished memories.

You could also paint a delightful mail box, welcome sign or use this technique on so many other items.

I love to watch all the birds that come to feed at our house.

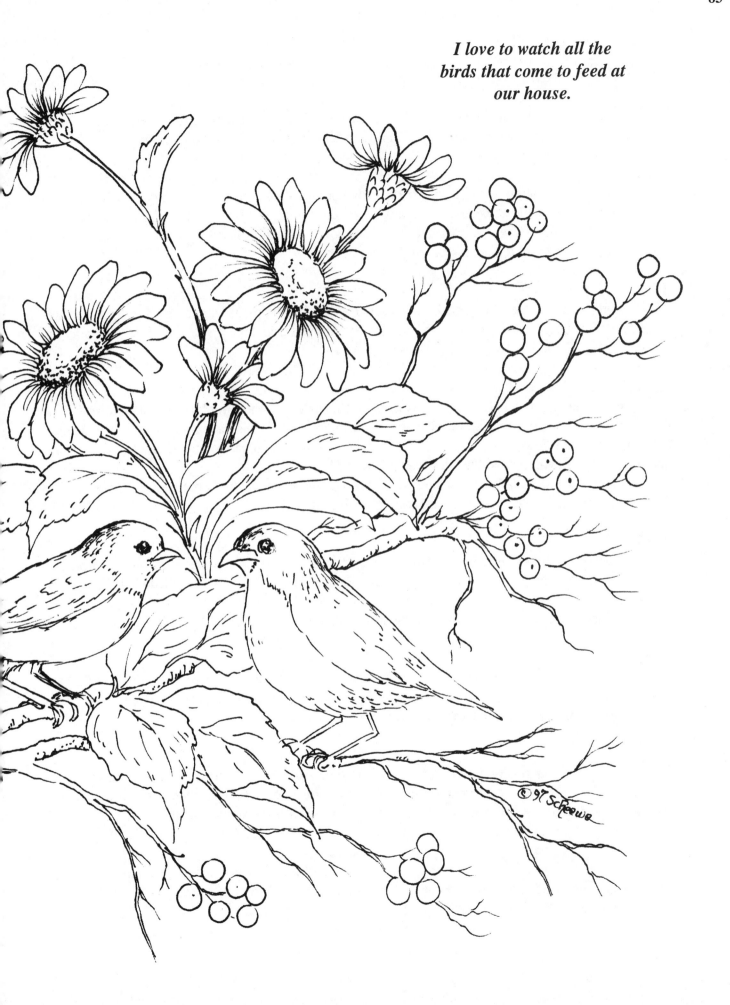

THRUSH Continued
STEP 1

Paint the surface with an acrylic color of you choice. Once the surface has dried you may want to create a design using a pencil, chalk pencil or graphite. Put acrylic paint on your palette.

STEP 2

Use a **No. 5 Round** to paint daisy petals. First be sure to wet the brush before you put the brush in the pigment. The delicate petals should have a variety of shapes. Brush direction is always important. Start at the tip of each petal, touch the brush down pull and lift upward. As you create these flower petals think of all the items you might paint them on.

STEP 3

Lightly tap the **No. 5 Round Brush** with **Opaque White,** paint up and down to form a center area. The white base coat will make a brighter center. Allow the center area to dry before you apply the yellow center. Clean your brush.

STEP 4

Paint the leaf area behind the birds using a **1/2 Inch Angular Shader**. Mix **Hookers Green Deep** with a little **Cadmium Yellow Medium**. You could paint all the leaves at this time or you could come back to them. Variations of greens, yellow tones and hints of blue violets make the leaves appear not only more colorful but, add depth to the painting.

Place the point of the angular brush to the outside edge of the leaf making a little scallop motion. If you refer to the photo in the book you will find it helpful.

STEP 5

Use a **No. 1 Liner** and **Mars Black** or **Indigo** to paint the small eyeball. It is so very surprising to see how much expression a little eye can make. Paint a _tiny_ dot of **Opaque White** highlight in the eye section.

Paint a very faint hint of yellow to the lower section.

STEP 6

Using the No. 1 Liner, paint the beak section using **Opaque White** with a little **Cadmium Yellow Medium** and a hint of **Burnt Umber**. Lighten the top section just a little. Apply a _very_ thin line of **Burnt Umber** to separate the top and bottom section.

STEP 7

Using a **1/2 Inch Angular Shader** with **Opaque White**, make short little strokes and apply to the chest and stomach area starting at the top of the chest. Brush direction is important as you paint this section. These little birds fly so fast it is a surprise to see their little round shapes.

While this white area is still wet, pick up a tiny bit of **Burnt Umber** and apply to the lower section, making a pleasant gradation of color. Rinse the brush.

On the point of the brush pick up just a tiny touch of **Cadmium Red Light** and **Magenta Deep**, apply just a little at the very top of the chest, just under the beak. Using this same color put a little at the top of the head. Wash your brush.

THRUSH Continued

STEP 8

Using a **No. 5 Round**, apply just a little **Burnt Umber** to the top back section. Add a hint of **Opaque White** and form a nice gradation of values.

Add just a little more **Opaque White** under the eye and then soften it out.

STEP 9

Using the **1/2 Inch Angular Shader** pick up **Burnt Umber** and paint the wing section and then come back and add hints of **Opaque White**.

STEP 10

Using a **No. 1 Liner**, put the brush in **Burnt Umber**, roll on the palette to remove excess pigment and then paint the leg.

STEP 11

The flower centers should now be dry. Lightly dab in the center again using **Cadmium Yellow Medium** and **Light**. Rinse the brush and tap on a little highlight. Very lightly tap in a hint of **Burnt Umber** to create a shadow towards the lower section.

STEP 12

Using acrylics it is very easy to form shadows on each of the petals around the center. Picking up a little diluted **Ultramarine Blue** and **Violet**, glide toward the center to create depth. It is so very easy to pull out just a hint of color on each petal.

STEP 13

Use either a **No. 5 Round** or **Angular Shader**, slide on the chisel edge to form branches. Dilute the pigment a little for easy flow.

STEP 14

It is always wonderful to include the family members when creating a gift. The little berries are simply painted using a cotton swab or Q-tip. You could easily have a child help with the application of these berries with a little direction. Test on scrap paper your results before going to your surface. These are done using **Cadmium Red Light** and hints of **Magenta Deep** and **Violet**. You could even add touches of yellow or add highlights with a tiny touch of **Opaque White**. First put the Q-tip in water, roll off excess water between your fingers and the dab in the pigment.

STEP 15

Using a **No. 5 Round Brush** or **No. 1 Liner**, apply your stems. Use the green mixtures on your palette. The acrylic will flow easier by adding just a little water.

Lightly dab a little color on the section at the base of the daisies. Make tiny little overlapping strokes.

FINISHING

Have a clean paper towel handy before you spatter your background. Add enough water to your **Opaque White** to create a soupy consistency. Using the **Angular Shader**, place your finger under the bristles and spatter on the surface of scrap paper first to check consistency and then spatter your surface. Blot unwanted spatters immediately.

I hope you enjoy this design. When doing the P.B.S. series, the 24 minute time factor makes it difficult to create as much detail as you could at home to your painting. I paint at a very fast speed ,

SPRING BOUQUET

**Susan Scheewe Acrylics
by Martin/F. Weber**
Opaque White S9011
Magenta Deep S9006
Cadmium Red Light S9002
Violet S9009
Ultramarine Blue S9008
Hookers Green Deep S9004
Cadmium Yellow Medium S9003
Indigo S9011
Cadmium Red Light S9002

**Susan Scheewe Brushes
by Martin/F. Weber**
Series S8038 1-1/2 Inch Background Brush
Series S8012 3/4 Inch Angular Shader
Series S8017 No. 1 Liner
Series 8037 or 8038 3/4 or 1 Inch Foliage
Series S8033 No. 0 Bristle Fan

MISCELLANEOUS SUPPLIES
140 lb. Cold Press or Memory Book
Tube Texture Medium S8555
Texture Medium Tips S8209

This beautiful spring bouquet is sure to brighten your room or paint this for a friend. Using acrylics to paint an album will make a perfect shower or birthday gift. The texture medium adds such delightful ease in creating the elegant basket. The design will find favor with your brides and traditional enough to be enjoyed as a timeless reminder of the special memories tucked inside. For a close friend or a relative of the bride it will be such a pleasure to compose a painting that will become a keepsake.

13.5 x 13" Contemporary Memory Album
WALNUT HOLLOW FARM
Dodgeville, Wi. 53522
Uses 12" x 12" Paper
Stock No. 3702

Using this palette, you can easily adjust the colors to those you most desire.

STEP 1

Seal the wood surface using White Lightening or acrylic base color. This could also be painted on watercolor paper.

STEP 2

Transfer the painting guide to the surface using graphite.

STEP 3

Paint the base for the lilacs. Start by tapping on mixture variations using **Opaque White**, **Violet** and **Magenta Deep** to form the base for the more detailed individual flowers. Go around the tulip shapes using the **Foliage Brush**. Lightly tap the base.

STEP 4

Using a **1/2 Inch Angular Shader**, paint the elegant tulip. Start at the top tulip working down the bouquet. Form the base by applying **Opaque White** mixed with a hint of **Cadmium Yellow Medium**. Pull this color from the stem toward the top of the petals forming the contour of the petal. On the point of the angular shader pick up **Magenta Deep**. You may select to mix this with **White** to form delicate pink or you may use more **Magenta** to deepen the value. Variations using a hint of **Violet** are nice. Apply color to the back petals edge, first pull and lift forming the gradation of color. Rinse and load the brush again to paint the forward petal. Brush direction is important.

SPRING BOUQUET Continued

STEP 5

Paint the tulip stems gliding the **1/2 Inch Angular Shader** or **No. 5 Round Brush** to form the gentle curve as it attaches to the flower. Pull a mixture of **White, Hookers Green Deep**, hint of **Cadmium Yellow Medium** and **Ultramarine Blue** to form the stems as well as up into the base of a few top flowers.

STEP 6

Using either a **1/2 Inch Angular Shader** or a **No. 5 Round Brush** to form the small four petal flowers on the lilac. Deepen a few areas using **Violet** with just a hint of **Opaque White**.

Apply just a few top flowers as an accent using more **White**.

STEP 7

Paint the leaves. There are more tulip blades than small leaves in this flower arrangement using a **1/2 Inch Angular Shader**. Allow the blades to form graceful curves. Use a mixtures of **White, Hookers Green Deep, Cadmium Yellow Medium** and **Ultramarine Blue**.

STEP 8

The basket is painted using a mixture of **White, Violet, Ultramarine Blue** and hint of **Magenta Deep**. Deepen the value on both sides using a **1/2 Inch Angular Shader**.

STEP 9

Paint the table area using a mixture of **Violet** and **White**. This could easily be changed to a color of your choice. Use the **1/2 Inch Angular Shader**.

STEP 10

The little butterfly is a delightful accent to the bouquet. It is easily added to the design by first applying **White** to the **1/2 Inch Angular Shader** and then pick up a hint of **Violet** or **Magenta Deep**. Using a liner with **Violet** for the body and antenna.

STEP 11

Use the texture medium to form the elegant design on the container. Place the small tube on the tip and pull across the container, spacing about a 1/2 inch apart, for each line. Go all one direction until all the lines have been formed.

STEP 12

Pull the lines crossing over the first application, going all the same direction. This will form your design.

STEP 13

Pull a gentle curving line to form the basket handle.

FINISHING

Now it is time to spatter the surface. Using a mixture of water, **Opaque White** with **Violet** and **Magenta Deep** spatter the surface using the foliage brush.

You can always come in and refine more detail, painting and shading each little flower on the lilacs.

I hope you will enjoy painting this project many more times for friends and loved ones. Enjoy.

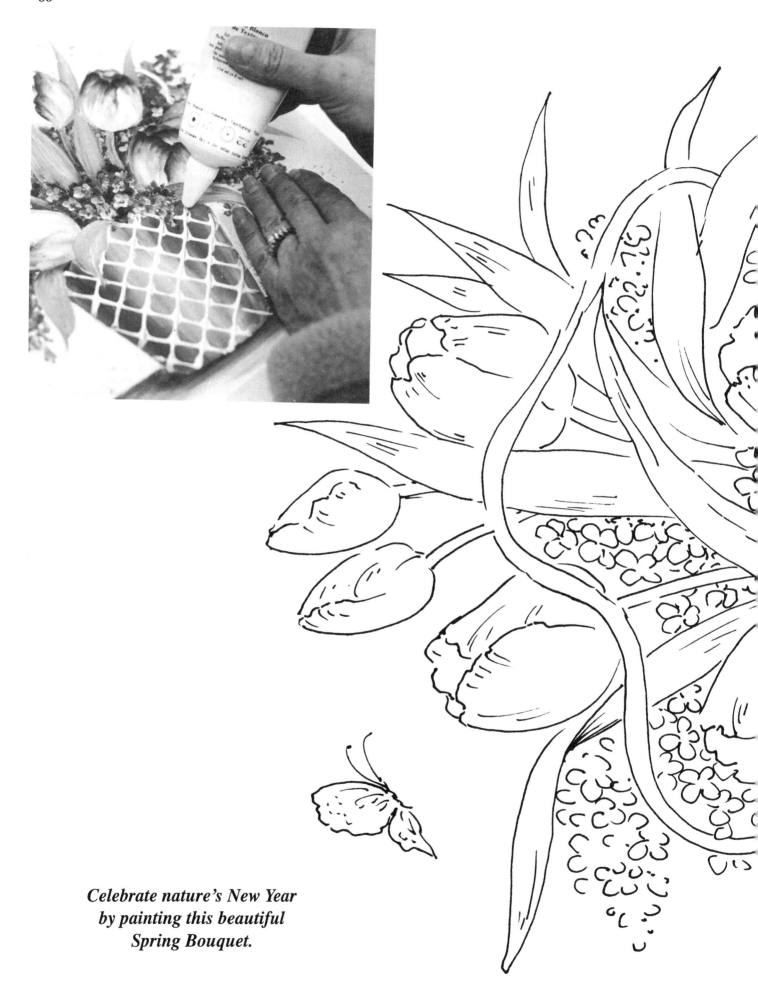

*Celebrate nature's New Year
by painting this beautiful
Spring Bouquet.*

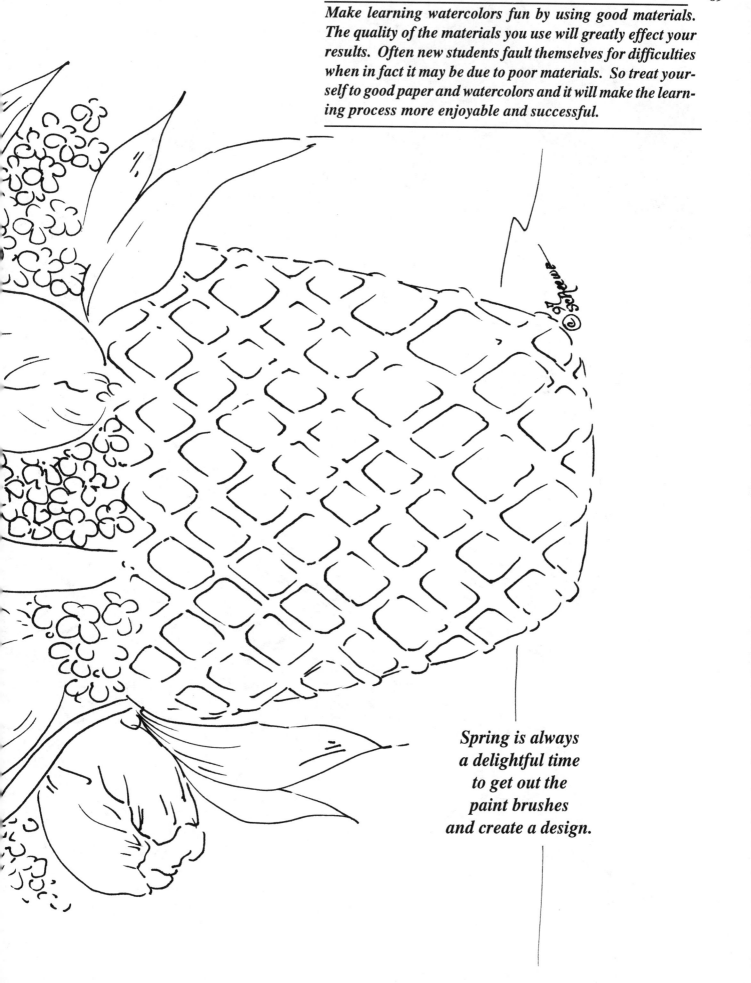

©Sheme

*Spring is always
a delightful time
to get out the
paint brushes
and create a design.*

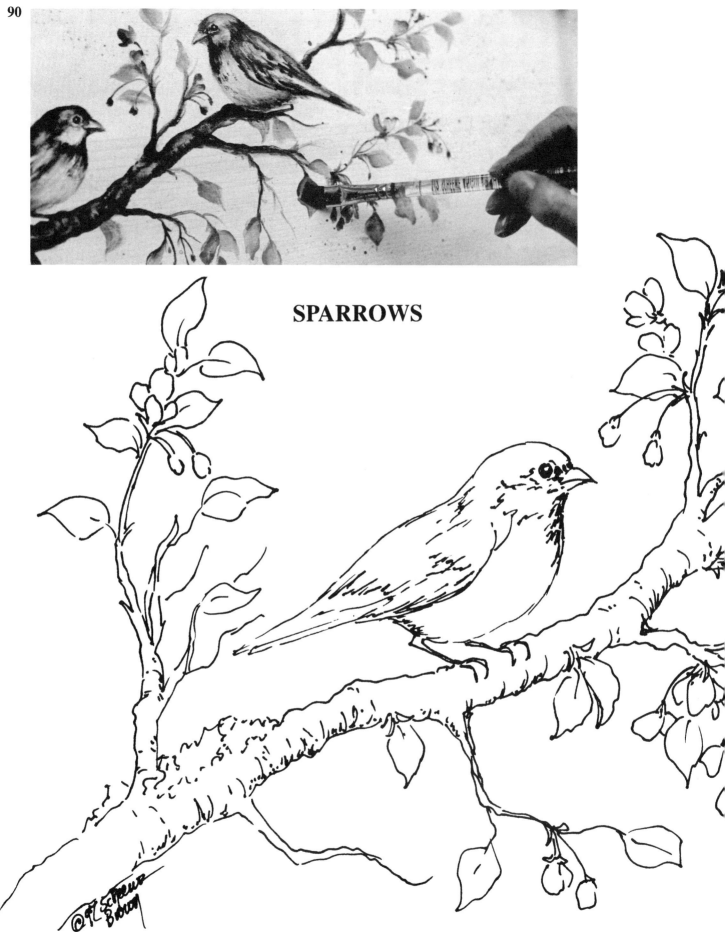

SPARROWS

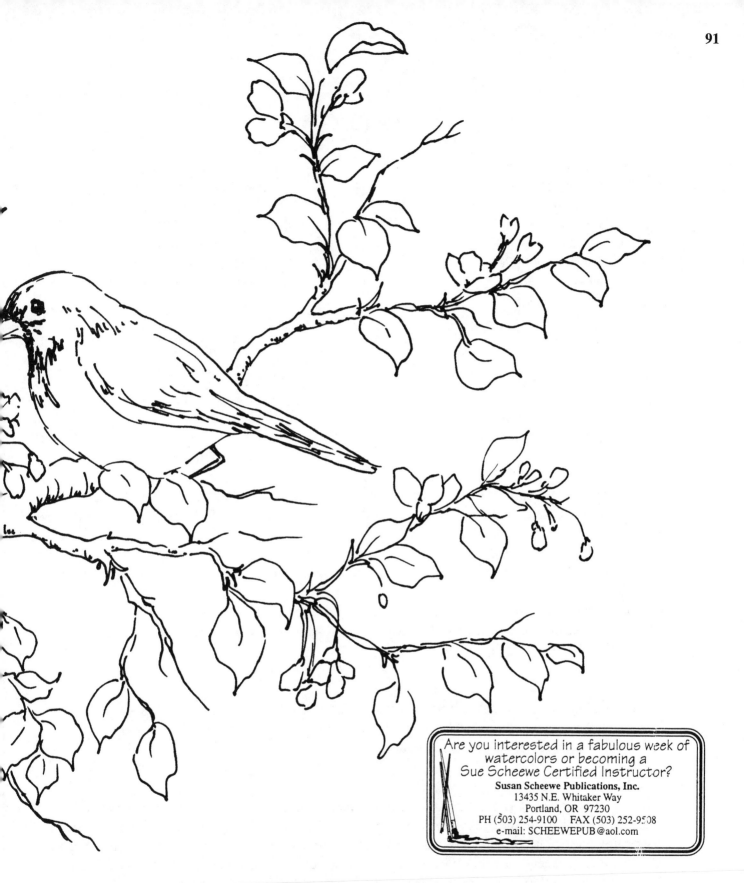

Watching someone else paint is to me much like enjoying a dancer or ice skater, it's like magic. When you have completed a painting the painting remains always as a memory of that moment in time. Those paintings done by a child become a treasured memory just as those done by a mother, father, grandma or just a loved one. Think about a painting you might have from a grandmother or grandfather and how you think of them as you view their work. Paintings can live beyond our time.

SPARROWS

Susan Scheewe Acrylics
by Martin/F. Weber
Opaque White S9011
Country Brick S9010
Burnt Umber S9001
Hookers Green Deep S9004
Ultramarine Blue S9008
Brilliant Cranberry S9014
Cadmium Yellow Medium S9003
Raw Sienna S9018

Susan Scheewe Brushes
by Martin/F. Weber
Series S8010 1/2 Inch Angular Shader
Series S8004 No. 5 Round
S8017 Size 1 Liner

Susan Scheewe Watercolors
by Martin/F. Weber
Opaque White S8407
Country Brick S8420
Burnt Umber S8412
Hookers Green Deep S8405
Ultramarine Blue S8419
Brilliant Cranberry S8411
Cadmium Yellow Medium S8413
Raw Sienna S8402

Miscellaneous
185 lb. Acrylic-Watercolor Paper S9070
Graphite S8205
Options
Birdhouse - Paper Lamp Shade

I so enjoy watching the little sparrows outside our kitchen window. We have bird feeders which bring a variety of birds. The little sparrow tucked into the shelter of the tree branches in the winter and enjoying spring sitting in the sun as the blossoms start to bloom.

You can create a beautiful watercolor painting or use acrylics to paint on a window shade with a birdhouse base, or decorate a childs crib or paint a welcome sign. The surfaces you select could be endless, however you could use much the same technique for painting the delightful little birds. I hope this project will show you how versatile your painting can be and serve as a springboard for more ideas. When I do these paintings on the P.B.S. series I have a time limit, but as you work there is no rush. Take your time and enjoy yourself.

STEP 1

Start with a pencil sketch or transfer your painting guide to your surface using a graphite sheet. You may want to make some sketches or photographs to use as a reference. When you draw what you see you will discover and absorb many details.

STEP 2

Use your **Size 1 Liner Brush** to paint the birds' eyes. This is an important step since proper placement and shape of the eyes will make your birds look realistic. Dip into **Burnt Umber**. You only need a tiny bit of paint, so roll your brush bristles on your palette to take off the excess. Very carefully fill the eye area except for a tiny spot of paper white which you will leave as a highlight. With watercolors, if you forget to leave some paper white, all is not lost. You can always use a dot of **Opaque White** to get the same effect. Apply a small dot of **Opaque White** for a highlight when using acrylics. A very common mistake is trying to paint human eyes on animals.

SPARROWS Continued

STEP 3

Paint the beak using a **No. 5 Round Brush** or smaller. Pick up a small amount of **Raw Sienna** on the tip of the brush. Leave a little area of paper white to separate the top and the bottom beak sections. If you are using acrylics, you will want to add **White**.

Be sure to paint this area with the shape feathering inward a little toward the head section.

STEP 4

As you start to paint the top section of the bird, leave a small unpainted area next to the eyeball. Start with light values using more water to lighten and then add dabs of stronger pigment to give a range of values. Let your strokes build the contours of the bodies. Variations in color will define the wings and add depth to your painting. Use **Burnt Umber** and hints of **Country Brick** allowing a few areas of paper white to remain.

If You are using acrylics, you will need to apply **White** to your mixture. Try not to overblend your colors. You can always come back and deepen the color.

STEP 5

Using a round brush, return with very little pressure to the beak section. This section should now be dry, use **Burnt Umber** to apply a tiny line to separate the upper and lower beak section.

STEP 6

Time to paint the lower section of the bird. Use a **1/2 Inch Angular Shader**, dip into clean water and pre-wet the breast area. Pick up a tiny bit of **Burnt Umber** on the point of your brush and lightly tap the pigment onto the breast.

With a hint of **Burnt Umber** yet on the brush, apply color to the bottom edge of the bird.

STEP 7

Use a **No. 1 Liner** to paint the legs and feet using **Burnt Umber**.

STEP 8

Before painting a hint of color in the background using watercolors, pre-wet the surface. Apply just a little diluted **Ultramarine Blue** and **Turquoise Deep**. Should you be using acrylic you could apply a transparent wash or a more opaque wash. Apply the pigment sparingly and let it diffuse so you get a very soft, misty look with just the slightest tint of color.

STEP 9

Paint the tree branches and twigs next. Using the **1/2 Inch Angular Shader**, place the point of the brush in **Burnt Umber** and then with a twist and a wiggle apply pigment to the outside edge, form the realistic appearance of these shapes. If you are using acrylic, you could first add **White** on the brush, then **Burnt Umber**. When using watercolor, use the white of the paper to form highlights. Twist the angle of the brush, lifting lightly at the end.

SPARROWS Continued

STEP 10

To paint the leaves, use your **1/2 Inch Angular Shader** and **Hookers Green Deep**. Check the color strength on your scrap paper as you touch the point of the brush in the pigment. Press lightly and give your brush a twist to form little leaf shapes. Your first layer could be very light and you can deepen the color by adding glazes. You may want to introduce other colors in the leaves such as hints of **Brilliant Cranberry**, **Cadmium Yellow Medium** and touches of **Country Brick**.

STEP 11

Now you will want to paint a few blossoms. Using your **1/2 Inch Angular Shader**, apply diluted **Brilliant Cranberry** just on the point of the brush. Should you be using acrylic, you should first dip in **White** and then put a touch of **Brilliant Cranberry** on the brush point.

Twist the brush to form the petals of each blossom with the point of the brush forming the outside edge. Vary the size, shape and directions of the small petals.

STEP 12

Using the **No. 1 Liner**, apply diluted **Burnt Umber** with a hint of **Hookers Green Deep** to form twigs and tendrils. Add a few touches of pigment on the branches to form the start of new leaves.

STEP 13

Additional dimension is added to the surface by spattering the surface. Keep a clean paper towel ready to blot unwanted pigment. Add enough water to your pigment to form a soupy consistency. Use diluted **Burnt Umber**, **Brilliant Cranberry** and **Hookers Green Deep**.

Hold the brush over your surface and lightly flick the brush with your fingertip placed under the bristles.

FINISH

Time to step back from the painting. Often adjustments are needed to add the finishing touches. Once the pigment is dry often accent changes are important.

PORTABLE TRAVEL BOARD

I love this portable travel board. It is the easiest way to support your paper while you work. The surface has been finished for easy clean up and can be wiped with a paper towel. The clips on the back fold out to give an excellent angle for working. The top clips hold the sheet at the top which makes it easy to carry when painting at different locations. Plus will hold a photo or a sketch for painting reference. Depending on the type of paper, you can easily tape the paper to the surface on all edges or just secure the top edge for heavier papers. The handle

Tight-fast Uni-Clips for holding various painting surfaces

HELPFUL HINTS

I've found while teaching, some areas that could be helpful as you learn more about watercolor. I've learned many of these helpful hints over the years, sometimes by making a mistake and by learning from my mistakes. I hope these hints will help you avoid some possible problems.

THE FIRST STEP IN PLANNING THE PAINTING IS JUST TAKING TIME TO THINK OF ALL THE STEPS YOU WANT TO TAKE. READ ALL THE INSTRUCTIONS BEFORE YOU START TO PAINT.

1. Make yourself a notebook. This notebook can be full of plastic sleeves containing color charts, tests using salt, special effects you've tried, sketches, paper and a reference as you experiment using watercolor and papers. Your notebook can be a wonderful source of material you have used and knowledge to refer to at a later date. Include brush technique, samples and special colors you've discovered that work well together.

2. Protect your paper prior to use. Be very careful not to damage the surface by accidentally scratching it with your fingernails, bracelet or painting knives. Don't store your paper where items could come in contact to scratch the surface. Be extra careful around the family cat, it could accidentally damage the surface with its claws.

3. Don't place hand lotion or oil on your hands prior to handling the paper surface. This could create an area that would repel the water.

4. Graphite papers can be helpful, but many create a problem due to oil or wax in the paper. I prefer Saral, as it works well for transferring my designs. Pencil can be used; allowing the pencil line to remain is permissible in watercolor. Removal of these lines can be done with a soft eraser. You may not find transfer paper available. An alternate is to rub a soft graphite pencil on the backside of tracing paper and then transfer to the surface.

5. Pencil erasers are most often too hard and can damage the paper surface should you rub too hard. Use a soft White eraser or gum eraser to remove unwanted lines.

6. Watercolors dry lighter than they appear when wet. There are several factors in how light a watercolor will dry, depending on the pigment, water and paper. As a good rule, always go lighter and deepen the color slowly.

7. ALWAYS start with light pigment and deepen slowly as you will create far less problems for yourself, especially with pigments that tend to stain the paper.

8. Should you accidentally splatter paint, immediately blot it with a clean soft towel or sponge.

9. Should you use a hair dryer to speed drying time, BE CAREFUL not to turn it on full blast next to the painting as it can cause the wet paint to move.

10. Be fair to yourself and use at least 140 lb. paper. It is easier to use cold press paper verses using rough paper.

11. When making greeting cards, buy the envelopes first and cut the paper to fit. Cards are fun to paint and a great way to practice your painting.

12. If you send a postcard remember to protect it from the elements.

13. Most often you will not want to over scrub the paper. Over scrubbing a paper could damage the surface. A good 140 lb. paper will be more forgiving to scrubbing, some of the more soft delicate papers can ball up.

14. Keep a clean damp sponge to lift off unwanted pigment.

15. Whatever you buy, the most important consideration is quality. The difference between poor brushes and paper and good material is the difference of making painting a struggle or fun.

16. Keep a scrap of paper to test colors and occasionally a technique. You can save the test paper with notes and add it to your notebook.

17. Remember, when following instructions from the book: IT IS YOUR PAINTING so if you want to deepen, lighten or change colors, you should do so. Color reproduction in print rarely appear exact to the original painting. Even when I do the same painting twice they rarely turn out the same.

18. Should you accidently forget to put the cap back on the watercolor tube and it has dried hard, cut the tube open. The paint is still good when dry, it only needs to be wet with water.

19. A little glycerin prolongs the drying time. If you are in a very dry area and working a large surface you may want to add a little to your water.

20. To speed drying add a little alcohol. This could be helpful in an extremely humid climate.

21. Try to enjoy watercolor as you learn new techniques. We all have some days that just don't turn out how we planned. If you can gather a sense of humor on those days it sure helps.

22. The color vary in how they stain the surface. There are some colors that are very strong staining and others that lift off with a little water. A good way to test this is to place a patch of color on the watercolor paper, let it set for several minutes. With clean water, try to rinse the color away. You should write the brand and color by each test area. Keep these tests for a reference in your watercolor notebook.

23. Use a water container that has a split for water and a rinse side for dirty water or work with two containers of water. Be careful of wipe cloths as you can accidently pick up color off of the rag. You can also accidently pick up color along the edge of the water container. Clean your container when it starts to get a lot of color buildup.

24. Brushes are one of your most important tools. Should you bend a brush accidently in storage you can most likely get the brush back into shape. If a natural hair brush should be out of shape, wash the brush in hot water, reshape and put gum arabic on the hair to hold the shape. If a synthetic brush should be out of shape, dip (not soak) in boiling water and put in gum arabic to reshape.

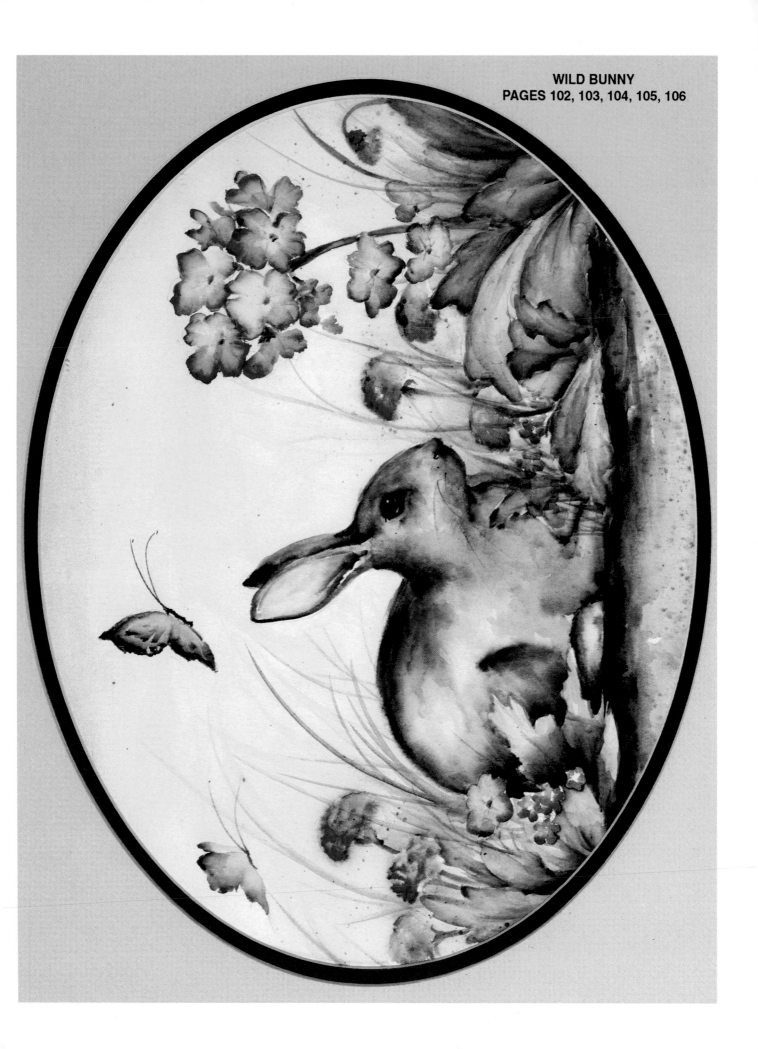

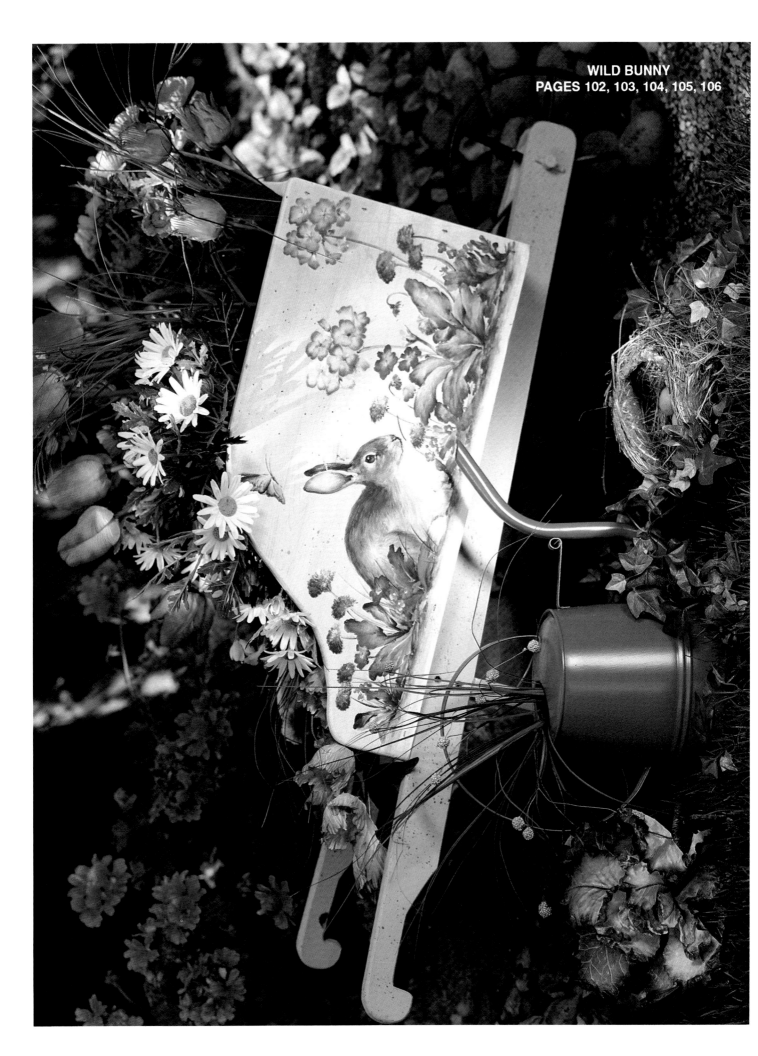

WILD BUNNY
PAGES 102, 103, 104, 105, 106

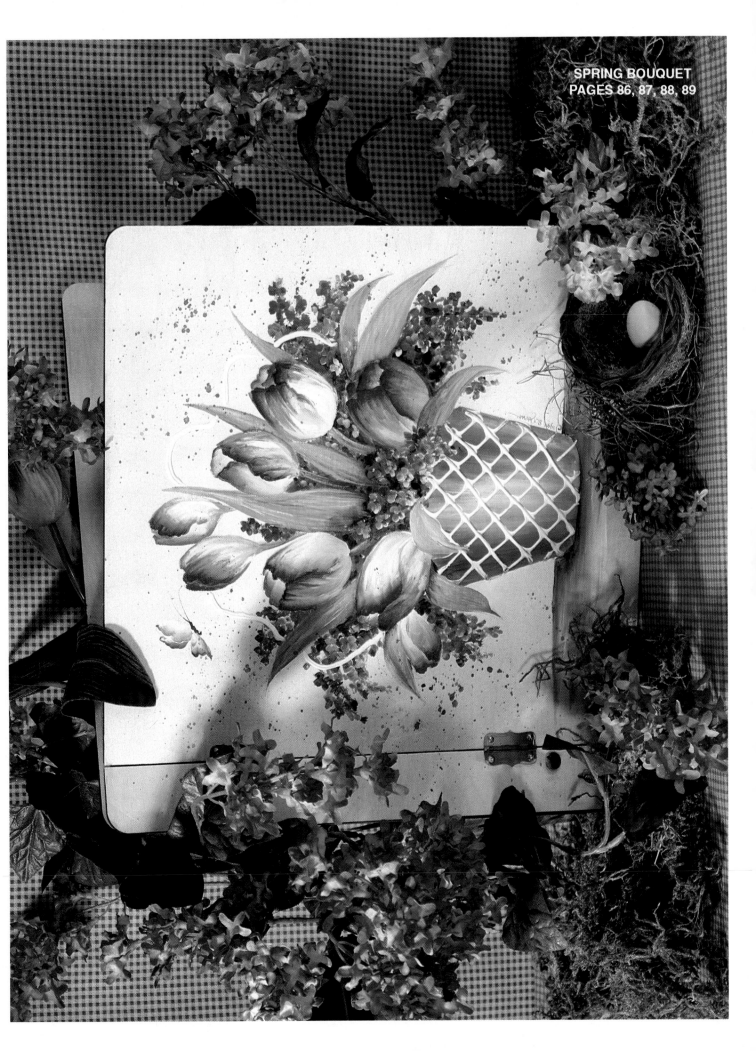

SPRING BOUQUET
PAGES 86, 87, 88, 89

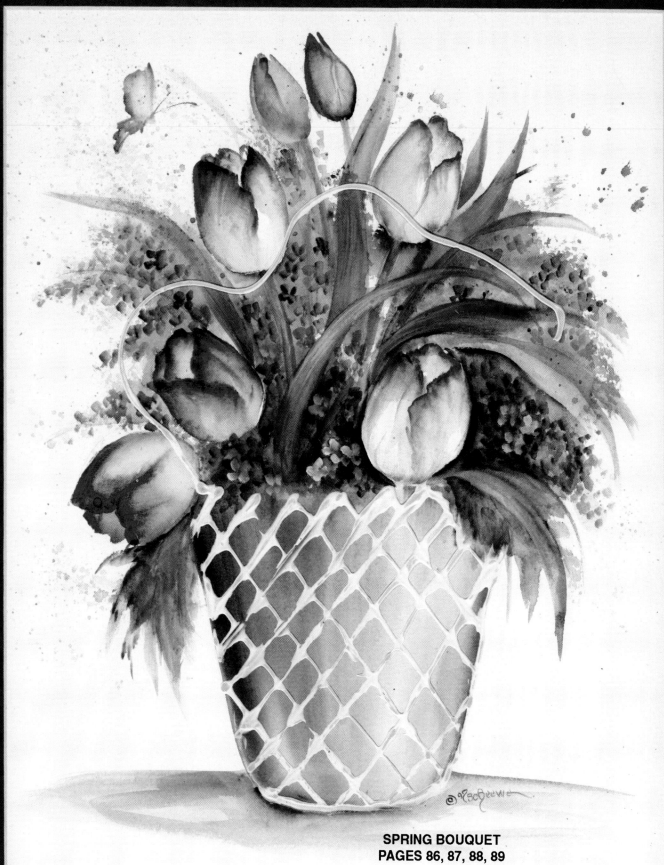

SPRING BOUQUET
PAGES 86, 87, 88, 89

25. Always store your brushes after they have been cleaned. Place a moth crystal in with your sable brushes if you don't plan to use them for awhile.

26. To help understand the meaning transparent, think of looking at a piece of stained glass, the light reflects off the paper through the paint.

27. Work on a greeting card or small painting to experiment with colors and techniques with the goal being simply to learn about the properties of the medium. After you gain confidence, repeat these techniques on a large painting.

28. Should you apply too much medium to a spot, it may crack when it dries. You can blot these areas with a CLEAN damp soft paper towel or remove with a damp brush by blotting the surface.

29. When painting trees start with a soft edge underpainting and allow this layer to dry before you start building forward. This soft diffused edge will create more depth in the painting.

30. When painting landscapes keep in mind soft gray blues recede in the background and warm brighter values will appear forward.

31. Be patient and allow drying time for your first underpainting before you start to apply a second layer.

32. Step back from your painting and look at it from a distance. Take a break if you are discouraged and come back with a fresh approach.

33. Having a reducing glass is a wonderful aid when painting as you can sit and look at areas in your painting as if you are stepping back from a painting.

34. If your clouds have a hard edge, you can soften them with a damp brush. The hard edge is created when painting on a dry surface.

35. When you are first starting to paint, use just a few colors and start with a simple painting. Be careful not to over challenge yourself and become discouraged.

COLOR CARE

After you apply paint onto the palette, wipe the top of the tube with a damp paper towel to clean away any traces of paint that would dry and make it hard to remove the cap when you use it again. Clean the cap as well if there are paint on the edges. Squeeze the paint from the bottom of the tube so you don't waste paint and suck in a lot of air that could cause the paint to dry some in the tube. Don't leave the caps off for a long period of time.

Should the tube cap become stuck try placing a match at the neck for a minute, be careful as the top will be hot and give it a turn.

If you find the paint has dried in the tube, as a last resort, cut open the tube and put the pigment on a palette. In my many years of painting this has only happened a couple times. There is nothing

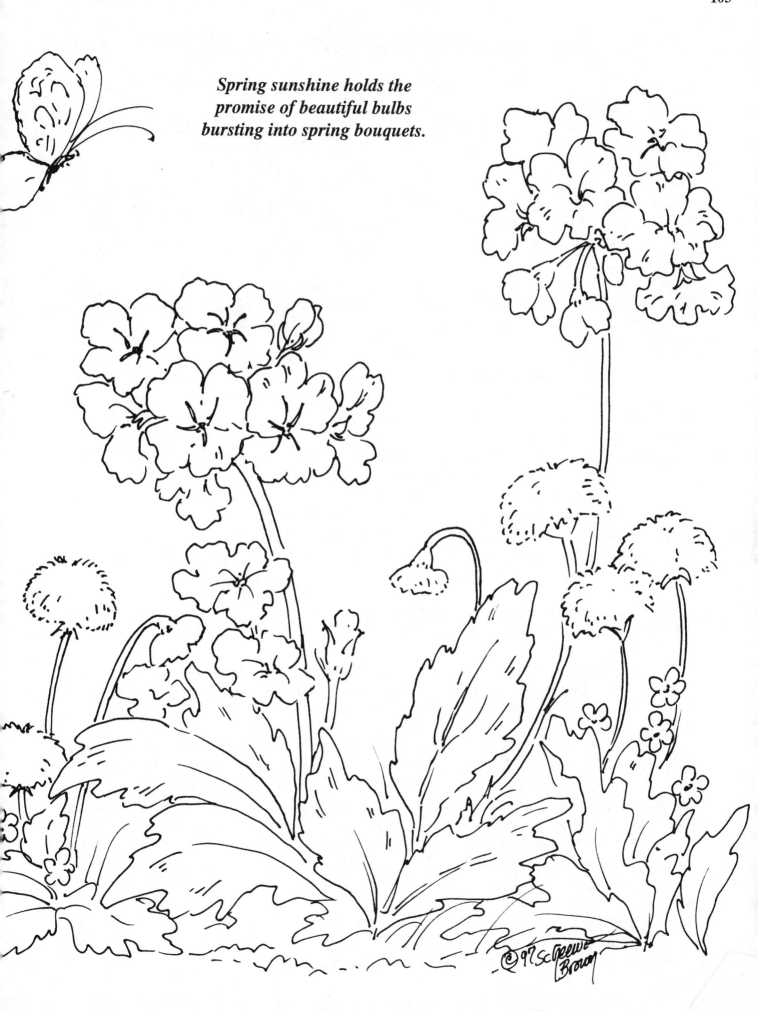

Spring sunshine holds the promise of beautiful bulbs bursting into spring bouquets.

WILD BUNNY

**Susan Scheewe Acrylics
by Martin/F. Weber**
Opaque White S9011
Burnt Umber S9001
Mars Black S9012
Magenta Deep S9006
Cadmium Yellow Pale S9015
Cadmium Yellow Medium S9003
Hookers Green Deep S9004
Indigo S9005
Cadmium Red Light S9002
Burnt Sienna S9000
Ultramarine Blue S9008
Turquoise Deep S9007

**Susan Scheewe Brushes
by Martin/F. Weber**
Series S8011 5/8 Inch Angular Shader
Series S8037 3/4 Inch Foliage Brush
Series S8032 Size 0 Bristle Fan
Series S8010 1/2 Inch Angular Shader
Series S8004 No. 5 Round
Supplies
185 lb Cold Press Watercolor/Acrylic Paper
Graphite SS8205
Sea Sponges S8203
Spray Bottle S8200

This darling bunny is tucked into the spring flowers. English daisies, forget-me-nots and primroses almost pop off the surface as you paint the delicate butterfly and bunny. You can paint this on a wonderful small wheelbarrow and fill it full of flower pots for spring. You also could paint this on a large basket to fill full of wonderful Easter surprises as you make an unforgettable childhood memory. Bring the spring colors into you home in a delightful watercolor. It's easier than you might think. When I was a child my Grandmother made me a basket I still remember as such a special surprise.

Using acrylics diluted much like a watercolor technique is a fun option. The acrylics dry permanent and you may consider your choice of pigments by the place you plan to put the painting. It is always a good idea to read all the instructions before you start to paint.

You could also apply more acrylic pigment to make a more opaque appearance.

STEP 1

Using a pencil or graphite, transfer the design or create one of your own. You may want to delete or add a few more flowers or butterflies. This tiny bunny is much like those that play at our warehouse.

Dampen the sea sponge to be ready to wipe or lift off pigment. Put out acrylic on a disposable palette and have a spray bottle handy to mist the paint on the palette.

STEP 2

Pre-wet the entire sheet until you see a shine. Apply a very diluted mixture of **Ultramarine Blue** and a hint of **Turquoise Deep** at the top of the sky area. You could paint using the portable art table. It lets you paint at an angle. This is not only helpful for your back, but also this angle is wonderful for creating a diffused appearance. Brush long horizontal strokes, starting at the top and working downward. As you work downward and the value should lighten. This should be done quickly before the water has time to evaporate. Continue to the next step as the English Daisies are started on the damp surface.

STEP 3

On the damp surface pick up just a tiny touch of **Magenta Deep** on the point of the **1/2 Inch Angular Shader** and then very lightly tap up and down to form English Daisies. Tap a little deeper value to the left. If the surface starts to dry, dampen with clean water.

WILD BUNNY Continued

STEP 4

I have so much fun painting animals I hope you will also enjoy painting them. Start with the eye to set the expression. Using acrylic you could mix **Burnt Umber** and **Mars Black**, however if you are using the watercolors use **Indigo**. Plan ahead to leave an unpainted paper white area (refer to the photo for placement). If you are working on a wood surface, clay pot or mailbox, add just a few dots of **Opaque White** to create a highlight.

Be careful not to paint a human eye shape on the animals.

STEP 5

Paint the inside ear section using the **1/2 Inch Angular Shader**. Pick up a tiny touch of **Burnt Sienna** and **Magenta Deep** on the point of the brush. Place the point of the brush at the bottom of the inside section, adding water to lighten as you work towards the top of this section. Wait for this area to dry before you continue painting the ears. Lightly spray your palette and clean your brush.

STEP 6

Pre-wet the body of the bunny with clean water. You want the surface to be wet enough to see a shine. Pick up a little **Burnt Umber** and hint of **Burnt Sienna** and apply to the back of the velvet bunny and along the hip line and feet. If you lightly tap the damp surface the pigment will softly diffuse. You can either gently pull the color to create a gradation of value or you may want to tap the surface lightly to form a soft spotted appearance.

STEP 7

Pick up a little more **Burnt Umber** and a hint of **Burnt Sienna** on the **Angular Brush**. Glide the brush along the edge of the forward ear.

While you are waiting for this area to dry, paint the face area. Dampen the surface to create a diffused appearance. Apply a little more pigment near the eye, but leave a lighter unpainted rim.

Deepen the value under the nose and along the chin line. Be careful not to make this area too rounded.

STEP 8

The delicate butterfly is painted next. You may want to do several more on your surface or get some cards and paint these along with the English Daisies for a spring greeting. Use the **Angular Shader** and pick up a touch of **Magenta Deep** and hint of **Ultramarine Blue**. Place the point of the brush toward the edge of the wings and glide on the shape.

Tap the bottom area of the wings to form a body. Use a **No. 5 Round Brush** and a hint of diluted **Mars Black** to accent the body and pull out antennas.

STEP 9

Paint the leaves next. Spray the palette with water. Using the **Angular Shader**, brush mix variations of green, using **Cadmium Yellow Pale**, **Cadmium Yellow Medium**, **Hookers Green Deep** and a hint of **Turquoise Deep**. Add blues diluted with enough water to become very transparent.

It may be easier for you to pre-wet each leaf before applying pigment which will then diffuse beautifully.

WILD BUNNY Continued

STEP 10

Paint the ground area. It is easier to pre-wet the entire ground area with clean water first. Pick up **Burnt Umber** and a hint of **Burnt Sienna** and tap on the pigment to create cast shadows. You may want to tap the area lightly with a sponge to form the appearance of texture in the ground.

For an option you can lay a sheet of paper over the bunny, leaves and flowers and spatter to form more interest.

STEP 11

You can either lightly tap on a suggestion of blue forget-me-nots or you can paint small detailed flowers using diluted **Ultramarine Blue** with hints of **Turquoise Deep**. You may want to add **Magenta Deep**. Use either a **Foliage Brush** or point of the **Angular Shader** forming each petal.

STEP 12

Primroses come in so many beautiful colors it is hard to pick a favorite. Very often they have a yellow center. First apply yellow to the center, using the **Angular Shader**. It may help you to pre-wet the flowers first, then tap in yellow which will diffuse easily. Pick up **Magenta Deep** and a hint of **Ultramarine Blue** on the point of the brush and glide the point along the edge which should form a gradation of color.

STEP 13

Pull down some stems using the green mixtures on your palette. Pull up grass blades by gliding and lifting the brush to form delicate blades that come to a taper. Be careful to vary the height, size and make sure not to pull them from the same spot.

STEP 14

Time to refine details. It is always a pleasure to share my love of painting and techniques on the P.B.S. series. I seldom have time to refine details in the time frame allotted. You can step back from your painting and come back later with a fresh eye and to add all sorts of little detail touches.

I so enjoy receiving your letters of how you put these painting techniques to use. Enjoy!

Susan Scheewe Publications Inc.

13435 N.E. Whitaker Way Portland, Or. 97230 PH (503)254-9100 FAX (503)252-9508 Orders Only (800)796-1953

WATERCOLOR BOOKS

Vol. 21	"Simply Watercolor" by Susan Scheewe Brown.....T.V. Book	260	$11.95 ___	
Vol. 24	"Introduction to Watercolor" by Susan Scheewe Brown.....T.V. Book	314	$11.95 ___	
Vol. 25	"Watercolors Anyone Can Paint" by Susan Scheewe Brown...T.V. Book	325	$11.95 ___	
Vol. 26	"Watercolor - The Garden Scene" by Susan Scheewe Brown... T.V. Book	339	$11.95 ___	
Vol. 27	"Watercolor Landscapes" by Susan Scheewe Brown....T.V. Book	360	$11.95 ___	
Vol. 28	"Watercolor - Garden Treasures" by Susan Scheewe Brown...T.V. Book	361	$11.95 ___	
Vol. 29	"Watercolor Collection" by Susan Scheewe Brown....T.V. Book	374	$11.95 ___	
Vol. 30	"Scheewe Art Workshop - Watercolor & Acrylic" by Susan Scheewe Brown..T.V. Bk.	398	$11.95 ___	
Vol. 31	"Enjoy Watercolor & Acrylic" by Susan Scheewe Brown.....T.V. Book	399	$11.95 ___	
Vol. 32	"Le Jardin" by Susan Scheewe Brown.....T.V. Book	414	$12.95 ___	
Vol. 33	"Simply Acrylic & Watercolor" by Susan Scheewe Brown.....T.V. Book	418	$12.95 ___	
NEW Vol. 34	"A Paintbox of Ideas" Vol. 1 by Susan Scheewe Brown.....T.V. Book	442	$12.95 ___	
NEW Vol. 35	"A Paintbox of Ideas" Vol. 2 by Susan Scheewe Brown.....T.V. Book	430	$12.95 ___	
NEW Vol. 36	"Welcomes-A Paintbox of Ideas" Vol. 3 by Susan Scheewe Brown. .T.V. Book	445	$12.95 ___	
NEW Vol. 37	"Paintbox Full of Animals" by Susan Scheewe Brown..T.V. Book	450	$12.95 ___	
Vol. 7	"Watercolor Journey" by Ellie Cook	381	$10.50 ___	
Vol. 3	"Watercolor Made Easy 3" by Kathie George	301	$10.50 ___	
NEW Vol. 4	"Watercolor Made Easy 4" by Kathie George	453	$10.50 ___	
Vol. 1	"Watercolor for Real" by Robert and Sharon Long	409	$10.50 ___	
Vol. 1	"The Way I Started" by Gary Hawk	120	$6.00 ___	
Vol. 1	"Watercolor Fun & Easy" by Beverly Kaiser	243	$7.50 ___	
Vol. 7	"Watercolor Charms" by Sharon Rachal	376	$10.50 ___	

VIDEOS BY SUSAN SCHEEWE BROWN

"Scheewe Art Workshop I" 13-1/2 HR Shows On 4 Tapes/ Introduction to Watercolors	S8225	$69.99
"Scheewe Art Workshop II" 13-1/2 HR Shows On 4 Tapes/ Watercolors Anyone Can Paint	S8223	$69.99
"Scheewe Art Workshop III" 13 - 1/2 HR Shows On 4 Tapes/ The Garden Scene	S8375	$69.99
"Scheewe Art Workshop III B" 13 - 1/2 HR Shows On 4 Tapes/ Watercolor Landscapes	S8376	$69.99
"Scheewe Art Wrokshop III C" 13 1/2 HR Shows on 4 Tapes/Garden Treasures	S8377	$69.99
"Scheewe Art Workshop III D" 13 - 1/2 HR Shows On 4 Tapes/Watercolor Collection	S8378	$69.99
"Scheewe Art Workshop IV A" 13 - 1/2 HR Shows On 4 Tapes/Scheewe Art Workshop-Watercolor & Acrylic	S8384	$69.99
"Scheewe Art Workshop IV B" 13 1/2 HR Shows On 4 Tapes/Enjoy Watercolor & Acrylic	S8385	$69.99
"Scheewe Art Workshop IV C" 13 1/2 HR Shows On 4 Tapes/Le Jardin(The Garden)	S8386	$69.99
"Scheewe Art Workshop IV D" 13 1/2 HR Shows On 4 Tapes/Simply Acrylic & Watercolor.	S8387	$69.99
"Watercolor Painting with Children" 1 Hour	S8222	$19.99 ___
"Paintbox In My Garden" 1 Hour	S8379	$19.99 ___
"Watercolor Techniques" 1 Hour	S8226	$19.99 ___
"Painting Projects" Watercolor 3 Hours...Trees and Leaves	S8224	$49.99 ___
"Acrylic Techniques For Everyone" I Hour	S8368	$19.99 ___

PEN & INK BOOKS / COLORED PENCIL BOOKS

Vol. 6	"Journey of Memories" by Claudia Nice	166	$6.50 ___	
Vol. 7	"Scenes from Seasons Past" by Claudia Nice	183	$10.50 ___	
Vol. 8	"Taste of Summer" by Claudia Nice	223	$10.50 ___	
Vol. 2	"Colored Pencil Made Easy" by Jane Wunder	242	$7.50 ___	
Vol. 3	"The Beauty of Colored Pencil and Ink Drawing" by Jane Wunder	259	$7.50 ___	
Vol. 4	"Watercolor, Pen and Ink" by Jane Wunder	357	$10.50 ___	
Vol. 5	"Watercolor, Pen and Ink, Vol. 2" by Jane Wunder	422	$10.50 ___	

5-1-00

LOOK FOR US ON-LINE!

REACH OUR WEB SITE AT:
http://www.painting-books.com

e-mail us: SCHEEWEPUB@aol.com

NAME _____

ADDRESS _____

CITY/STATE/ZIP _____

PH() _____

VISA _____

M/C _____

EXP.DATE _____

SHIPPING$ _____

OILS BOOKS

Vol. 1	"His and Hers" by Susan Scheewe	101	$6.50 ___	
Vol. 7	"Paint 'n Patch" by Susan Scheewe	107	$5.50 ___	
Vol. 11	"I Love To Paint" by Susan Scheewe	111	$6.50 ___	
Vol. 2	"Western Images 2" by Becky Anthony.....*NEW	436	$10.50 ___	
Vol. 5	"Soft Petals" by Georgia Bartlett	171	$6.50 ___	
Vol. 6	"Painting Fantasy Flowers" by Georgia Bartlett	215	$7.50 ___	
Vol. 8	"Petals" by Georgia Bartlett	317	$10.50 ___	
Vol. 9	"Floral Medley" by Georgia Bartlett	344	$10.50 ___	
Vol. 10	"Flower Show" by Georgia Bartlett	415	$10.50 ___	
Vol. 4	"Countryscapes" by Donna Bell	249	$10.50 ___	
Vol. 5	"Painter to Painter" by Donna Bell	263	$10.50 ___	
Vol. 6	"Landscapes With Acrylics & Oil" by Donna Bell	282	$10.50 ___	
Vol. 1	"Natures Palette" by Carol Binford.....O/AC	248	$10.50 ___	
Vol. 2	"Oil Painting The Easy Way" by Bill Blackman	337	$10.50 ___	
Vol. 3	"Acrylic Painting Made Easy" by Bill Blackman.....*NEW	460	$10.50 ___	
Vol. 3	"Lighted Windows & Gardens" by Bill Blackman	355	$10.50 ___	
Vol. 1	"Wildflower Studio" by Rachal Britt.....*NEW	457	$10.50 ___	
Vol. 2	"Mini Mini More" by Terri and Nancy Brown	151	$6.50 ___	
Vol. 4	"Heritage Trails" by Terri and Nancy Brown	169	$6.50 ___	
Vol. 4	"Windows Of My World 4" by Jackie Claflin	359	$10.50 ___	
Vol. 5	"Windows of My World 5" by Jackie Claflin.....*NEW	447	$10.50 ___	
Vol. 6	"Windows of My World 6" by Jackie Claflin.....*NEW	464	$10.50 ___	
Vol. 1	"Enchanting Colors of the Southwest" by Patsy Delk	441	$10.50 ___	
Vol. 1	"Expressions In Oil" by Delores Egger	154	$6.50 ___	
Vol. 4	"Expressions In Oil" by Delores Egger	239	$7.50 ___	

Vol. 2	"Days of Heaven" by Gloria Gaffney	252	$10.50 ___	
Vol. 6	"The Sky's The Limit" by Jean Green	372	$10.50 ___	
Vol. 3	"Nature's Beauty" by Bill Huffaker	177	$6.50 ___	
Vol. 1	"Ducks and Geese" by Jean Lyles	172	$6.50 ___	
Vol. 1	"Raining Cats & Dogs" by Todd Mallett	304	$10.50 ___	
Vol. 1	"Another Path To Follow" by Lee McGowen	328	$10.50 ___	
Vol. 2	"Bitterroot Backroads 2" by Glenice Moore	340	$10.50 ___	
Vol. 3	"Bitterroot Backroads 3" by Glenice Moore	369	$10.50 ___	
Vol. 4	"Bitterroot Backroads 4" by Glenice Moore. ACRYLIC*NEW	478	$10.50 ___	
Vol. 1	"Stepping Stones" by Judy Nutter	121	$6.50 ___	
Vol. 1	"Painting with Paulson" by Buck Paulson	343	$11.95 ___	
Vol. 1	"Rustic Charms" by Sharon Rachal	175	$6.50 ___	
Vol. 2	"Rustic Charms II" by Sharon Rachal	199	$10.50 ___	
Vol. 1	"Painting Flowers With Augie" by Augie Reis	152	$6.50 ___	
Vol. 3	"Realistic Technique" by Judy Sleight	341	$10.50 ___	
Vol. 2	"Soft & Misty Paintings" by Kathy Snider	229	$10.50 ___	
Vol. 2	"Fantasy Folk" by Don Weed	123	$6.50 ___	
Vol. 1	"Something Special For Everyone" by Mildred Yeiser	158	$6.50 ___	
Vol. 5	"Soft & Gentle Paintings" by Mildred Yeiser	268	$10.50 ___	
Vol. 2	"Friends Are Forever" by Gene Waggoner	231	$10.50 ___	
Vol. 1	"Guardians of The Light" by Diane Nielson Wallace.*NEW	468	$10.50 ___	

SHIPPING & HANDLING CHARGES
Add $3.00 for the First Book for shipping and handling.
Add $1.50 per each additional book.
Please Add $4.00 for handling & postage. PER TAPES. Sorry
we must have a "NO REFUND - NO RETURN" policy.
U.S CURRENCY

Susan Scheewe Publications Inc.

13435 N.E. Whitaker Way Portland, Or. 97230 PH (503)254-9100 FAX (503)252-9508 Orders Only (800)796-1953

ACRYLIC BOOKS

Vol.	Title	#	Price
Vol. 2	'Country Heartworks 2" by Reed Baxter	365	$10.50
Vol. 1	"Kids And Water" by Joyce Benner	234	$10.50
Vol. 2	"The Flower Market" by Joyce Benner	319	$10.50
Vol. 3	"Acrylic Painting The Easy Way" by Bill Blackman *NEW	460	$10.50
Vol. 3	"Country Fixin's - For All Seasons" by Rhonda Caldwell	332	$10.50
Vol. 1	"Country Celebration" by Tammy Christensen	378	$10.50
Vol. 1	"Folkart Friends" by Darcy Christensen	437	$10.50
Vol. 1	"A Painters Garden " by Jane Dillon	354	$10.50
Vol. 3	"A Painters Garden 3" by Jane Dillon	458	$10.50
Vol. 1	"Santas and Sams" by Bobi Dolara	258	$10.50
Vol. 2	"Vintage Peace" by Bobi Dolara	270	$10.50
Vol. 2	"Floral Designs 2" by Carol Empet	338	$10.50
Vol. 3	"Floral Portraits" by Carol Empet	358	$10.50
Vol. 1	"Angels Are Near" by Carol Freeman & Brenda Turley	375	$10.50
Vol. 2	"Briar Patch #2" by Sandy Fochler	424	$10.50
Vol. 3	"Briar Patch #3" by Sandy Fochler	456	$10.50
Vol. 4	"Briar Patch #4" by Sandy Fochler *NEW	479	$10.50
Vol. 1	"Between Friends-Briar Patch" by Sandy Fochler, Lorrie Dirksen, Holly Jespersen, Bonnie Morello	448	$10.50
Vol. 2	"Between Friends 2-Briar Patch"by Sandy Fochler, Lorrie Dirksen, Holly Jespersen, Bonnie Morello *NEW	473	$10.50
Vol. 2	"Deck The Halls Bauernmalerei" by Sherry Gall	391	$10.50
Vol. 1	"Olde Thyme Folk Art" by Teresa Gregory	390	$10.50
Vol. 2	"Country Thyme" by Teresa Gregory	406	$10.50
Vol. 1	"Maple Sugar" by Roberta Hall	444	$10.50
Vol. 2	"Maple Sugar 2" by Roberta Hall *NEW	461	$10.50
Vol. 3	"Maple Sugar 3" by Roberta Hall *NEW	471	$10.50
Vol. 4	"Maple Sugar 4" by Robert Hall *NEW	481	$10.50
Vol. 2	"A Little For Every Holiday" by Vickie Higley *NEW	477	$10.50
Vol. 1	"Holiday Gathering" by Angie Hupp	267	$10.50
Vol. 3	"Heavenly Gathering" by Angie Hupp	320	$10.50
Vol. 1	"Painted Jars" by Conny Hubbard	454	$10.50
Vol. 1	"Happy Heart, Happy Home" by Cathy Jones	241	$10.50
Vol. 1	"Dandelions" by Carla Kern	416	$10.50
Vol. 1	"Festive Collectibles" by Deborha Kerr *NEW "Collectors Release"	279	$10.50
Vol. 2	"Serendipity Collectibles" by Deborha Kerr *NEW "Collectors Release"	289	$10.50
Vol. 1	"Painted Memories, A Mother's Love" by Deborha Kerr	435	$10.50
Vol. 1	"Pickets & Pastimes" by Marie & Jim King	329	$10.50
Vol. 3	"Pickets & Pastimes 3, Feathered Inn" by M. & J. King	385	$10.50
Vol. 1	"For Me & My House" by Myrna King	370	$10.50
Vol. 1	"Huckleberry Horse" by Hanna Long	269	$10.50
Vol. 2	"Love Lives Here" by Mary Lynn Lewis	185	$6.50
Vol. 3	"Love Lives Here" by Mary Lynn Lewis	195	$6.50
Vol. 1	"Everything Under The Moon" by Jackie Ludwig	421	$10.50
Vol. 4	"The Pocket Patch Vol. 4" by Sara Massey	446	$10.50
Vol. 1	"Second Nature" by Kathy McPherson	427	$10.50
Vol. 2	"Second Nature 2" by Kathy McPherson *NEW	463	$10.50
Vol. 6	"Special Welcomes #6 Crop Keepers" by Corinne Miller	347	$10.50
Vol. 4	"Bitterroot Backroads 4" by Glenice Moore *NEW	478	$10.50
Vol. 1	"Fruit & Flower Fantasies" by Joyce Morrison	277	$10.50
Vol. 2	"Fruit & Flower Fantasies 2" by Joyce Morrison	382	$10.50
Vol. 1	"Whimsical Critters" by Lori Ohlson	228	$7.50
Vol. 2	"Sunflower Farm" by Lori Ohlson	326	$10.50
Vol. 1	"Friends Forevermore" by Karen Ortman	434	$10.50
Vol. 2	"Friends Forevermore 2" By Karen Ortman *NEW	462	$12.95
Vol. 1	"Holiday Medley" by Nina Owens	265	$10.50
Vol. 2	"Another Holiday Medley" by Nina Owens	296	$10.50
Vol. 1	"Gifts & Graces" by Charlene Pena *NEW	475	$10.50
Vol. 1	"Oh Those Little Rascals" by Diane Permenter	247	$10.50
Vol. 2	"Tailfeathers 2" by Gisele Pope & Carla Kern	451	$10.50
Vol. 3	"Tailfeathers 3" by Gisele Pope & Carla Kern *NEW	476	$10.50
Vol. 8	"Now & Then" by La Rae Parry	428	$10.50
Vol. 1	"Between The Vines" by Jamie Mills Price	400	$10.50
Vol. 2	"Between The Vines 2" by Jamie Mills Price	419	$10.50
Vol. 3	"Between The Vines 3" by Jamie Mills Price	449	$12.95
Vol. 4	"Between The Vines 4" by Jamie Mills Price *NEW	474	$12.95
Vol. 1	"Forever In My Heart" by Diane Richards.....AC/Fabric	188	$6.50
Vol. 2	"Memories In My Heart" by Diane Richards.....AC/Fabric	189	$6.50
Vol. 3	"Forever In My Heart II" by Diane Richards.....AC/Fabric	205	$10.50
Vol. 6	"Angels In My Stocking" by Diane Richards	254	$10.50
Vol. 7	"Nostalgic Dreams" by Diane Richards	273	$10.50
Vol. 8	"Heavenly Treasures" by Diane Richards *NEW	472	$10.50
Vol. 1	"Country Classics" by Karen Rideout	413	$10.50
Vol. 2	"Country Classics 2" by Karen Rideout *NEW	465	$10.50
Vol. 1	"Country Fun For Chistmas" by Tina Rodrigues	367	$10.50
Vol. 2	"Country Fun 2" by Tina Rodrigues	383	$10.50
Vol. 3	"Country At Heart" by Tina Rodrigues	401	$10.50
Vol. 4	"Country At Heart 4" by Tina Rodrigues	410	$10.50
Vol. 1	"Kracker Jack Kritters" by Kathie Rueger	405	$10.50
Vol. 4	"Keepsake Sampler" by Susan & Camille Scheewe	200	$10.50
Vol. 1	"Schoolhouse Treasures" by Cathy Schmidt	408	$10.50
Vol. 2	"Schoolhouse Treasures" by Cathy Schmidt	433	$10.50
Vol. 1	"Holiday Hangarounds" by Marsha Sellers	327	$10.50
Vol. 1	"Huckleberry Friends" by Cheryl Seslar	393	$10.50
Vol. 2	"Huckleberry Friends 2" by Cheryl Seslar	403	$10.50
Vol. 3	"Huckleberry Friends 3" by Cheryl Seslar	431	$10.50
Vol. 1	"Creations In Canvas...and More" by Carol Spooner	256	$10.50
Vol. 1	"Gran's Garden" by Ros Stallcup	295	$10.50
Vol. 2	"Another Gran's Garden" by Ros Stallcup	315	$10.50
Vol. 3	"Gran's Garden & House" by Ros Stallcup	334	$10.50
Vol. 4	"Gran's Garden Party" by Ros Stallcup	345	$10.50
Vol. 5	"Gran's Treasures" by Ros Stallcup	363	$10.50
Vol. 6	"Gran's Gifts" by Ros Stallcup	387	$10.50
Vol. 7	"Gran's Welcome" by Ros Stallcup	425	$10.50
Vol. 8	"Gran's Marketplace" by Ros Stallcup	426	$12.95
Vol. 9	"Gran's Flower Shoppe" by Ros Stallcup	452	$12.95
Vol. 10	"Gran's Magic-Bells, Books & Candles" by Ros Stallcup *NEW	466	$12.95
Vol. 11	"Gran"s Attic" by Ros Stallcup *NEW	483	$12.95
Vol. 2	"Blackberry Hollow" by Margaret Steed	407	$10.50
Vol. 1	"Keepsakes For The Holidays" by Charleen Stempel & S. Scheewe	286	$10.50
Vol. 1	"Mrs. McGregors Garden" by Charleen Stempel	316	$10.50
Vol. 1	"Christmas Greetings from the Cottage" by Chris Stokes	336	$10.50
Vol. 1	"Christmas Visions" by Max Terry	278	$10.50
Vol. 3	"Painting Clay Pot-pourri" by Max Terry	310	$10.50
Vol. 1	"Country Primitives" by Maxine Thomas	274	$10.50
Vol. 2	"Country Primitives 2" by Maxine Thomas	300	$10.50
Vol. 3	"Country Primitives 3" by Maxine Thomas	322	$10.50
Vol. 4	"Country Primitives 4" by Maxine Thomas	350	$10.50
Vol. 5	"Country Primitives 5" by Maxine Thomas	392	$10.50
Vol. 6	"Country Primitives 6" by Maxine Thomas	429	$10.50
Vol. 7	"Country Primitives 7" by Maxine Thomas	459	$10.50
Vol. 8	"Country Primitives 8" by Maxine Thomas *NEW	482	$10.50
Vol. 1	"Rise & Shine" by Jolene Thompson	214	$6.50
Vol. 1	"Count Your Blessings" by Chris Thornton	213	$10.50
Vol. 6	"Share Your Blessings" by Chris Thornton	226	$10.50
Vol. 7	"Blessings" by Chris Thornton	255	$10.50
Vol. 9	"Blessings For The Home" by Chris Thornton	275	$10.50
Vol. 11	"Painted Blessings" by Chris Thornton	323	$10.50
Vol. 12	"Family Blessings" by Chris Thornton	349	$10.50
Vol. 15	"Multitude of Blessings" by Chris Thorton	379	$10.50
Vol. 17	"Blessings For The Home & Garden" by Chris Thornton	423	$12.95
Vol. 18	" Blessings To Treasure" by Chris Thornton	438	$10.50
Vol. 19	"Blessings To Share" by Chris Thornton *NEW	470	$10.50
Vol.1	"Watermelon Wedges and Rustic Edges " by Lorinne Thurlow	342	$10.50
Vol. 2	"Farmer and Friends" by Lou Ann Trice	366	$10.50
Vol. 2	"Jars, Jars, Jars!" by Cindy Trombley *NEW	469	$10.50
Vol. 5	"Daydreams & Sweet Shirts II" by Don & Lynn Weed	208	$10.50
Vol. 1	'Pitter-Patter-Pigtail-Girls! A Simpler Thyme"by Stacy Gross West	432	$10.50
Vol. 1	"Country Doodles" by Amanda Williams	455	$10.50
Vol. 1	"All Of The Holidays" by Chris Williams	443	$10.50
Vol. 1	"Connie's Favorite Old-Time Labels" by Connie Williams	335	$10.50
Vol. 2	"Connie's Garden Seed Packets" by Connie Williams	351	$10.50
Vol. 1	"Floral Fabrics and Watercolor" by Sally Williams	262	$10.50
Vol. 1	"A Time For Giving" by Evelyn Wright	308	$10.50
Vol. 2	"Heart Full of Whimsy 2" by Mariellen Youngdahl *NEW	467	$10.50

NAME _____ 5-1-00

ADDRESS _____

CITY/STATE/ZIP _____

PH () _____

VISA _____

M/C _____

EXP. DATE _____

SHIPPING $ _____

SHIPPING &
HANDLING
CHARGES
Add $3.00 for the First Book for shipping and handling.
Add $1.50 per each additional book.

Please Add $4.00 for handling & postage. PER TAPES. Sorry we must have a "NO REFUND - NO RETURN" policy.

LOOK FOR US ON-LINE!

REACH OUR WEB SITE AT:
http://www.painting-books.com

e-mail us: scheewepub@aol.com

PRICES SUBJECT TO CHANGE WITHOUT NOTICE

Check out our WEB SITE at: //www.painting-books.com

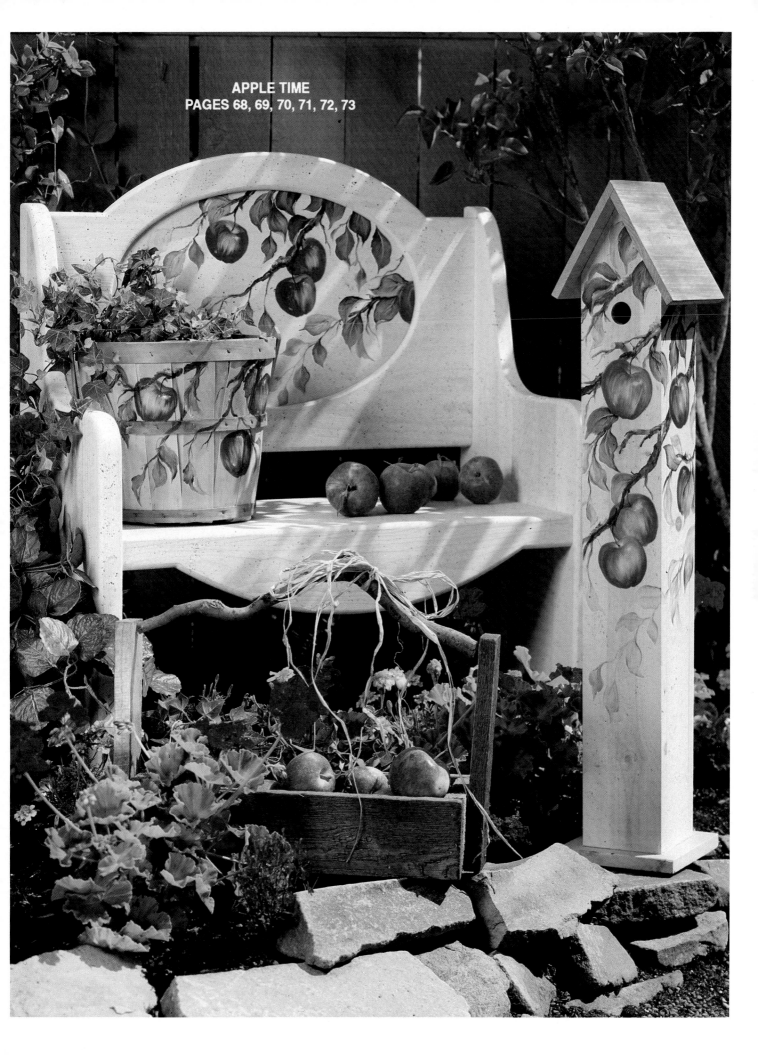

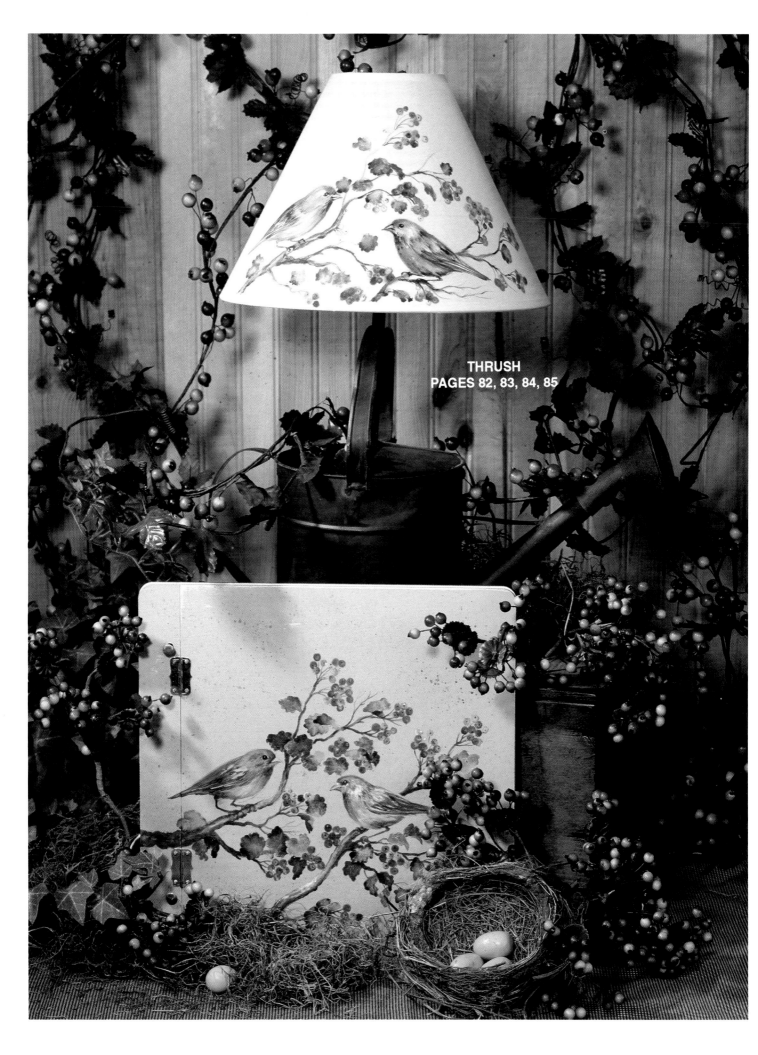

THRUSH
PAGES 82, 83, 84, 85

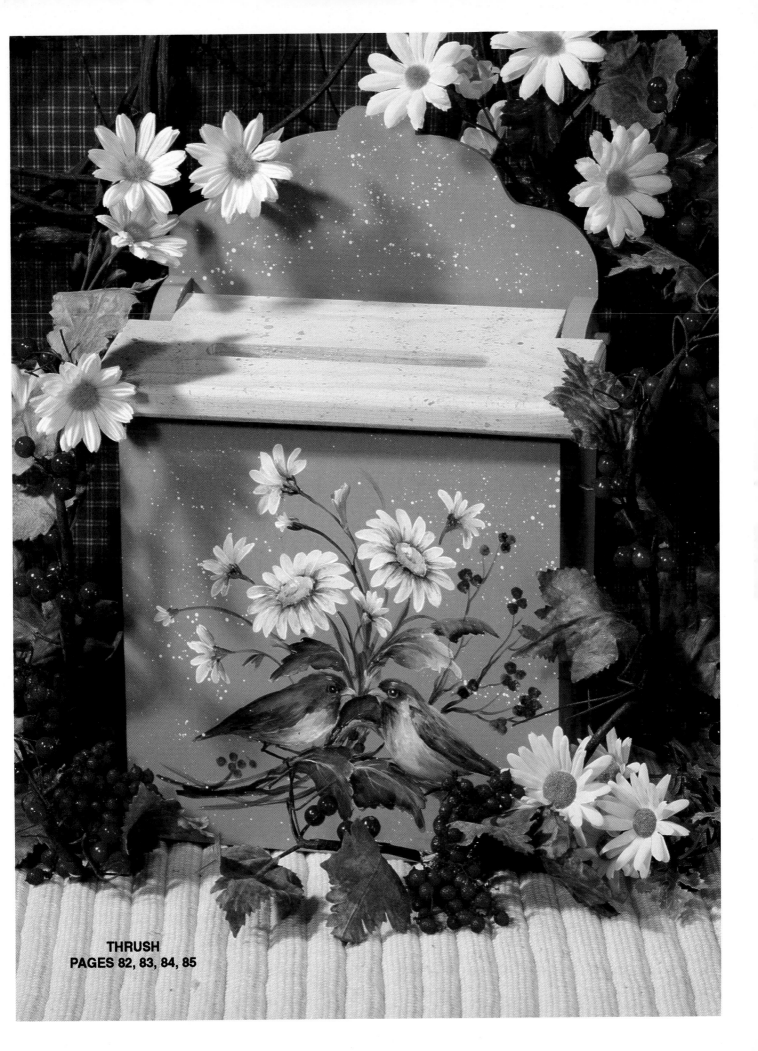

THRUSH
PAGES 82, 83, 84, 85

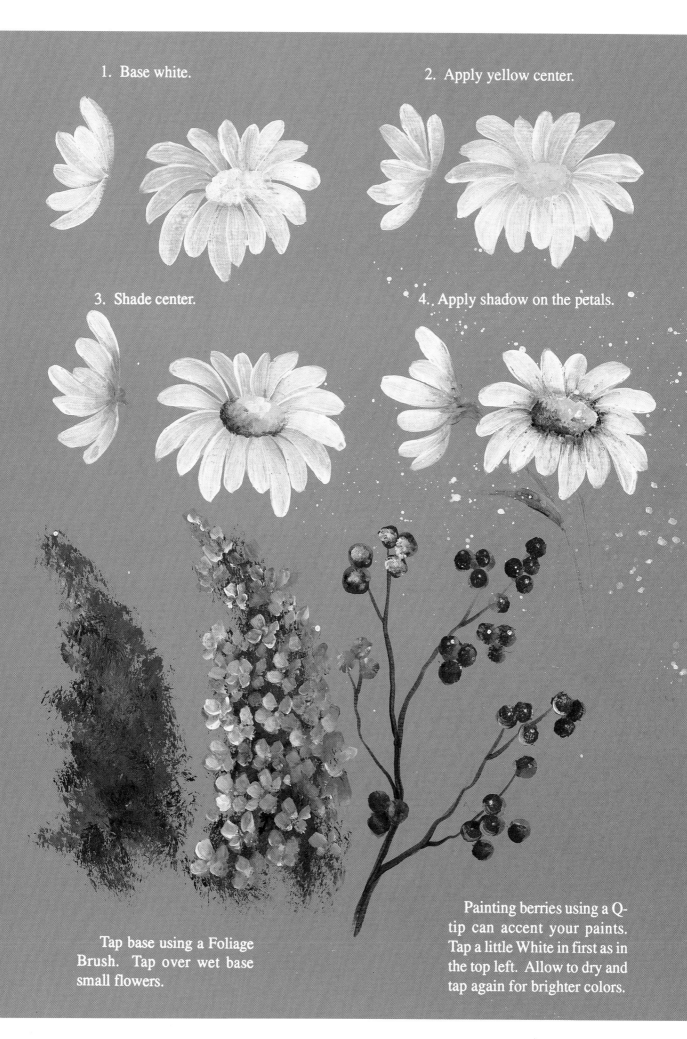

1. Base white.

2. Apply yellow center.

3. Shade center.

4. Apply shadow on the petals.

Tap base using a Foliage Brush. Tap over wet base small flowers.

Painting berries using a Q-tip can accent your paints. Tap a little White in first as in the top left. Allow to dry and tap again for brighter colors.